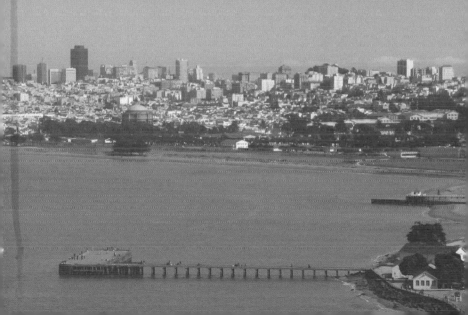

SAN FRANCISCO

architecture & design

Edited by Michelle Galindo
Written by Melody Mason
Concept by Martin Nicholas Kunz

teNeues

content

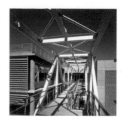

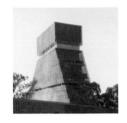

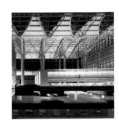

to see . culture & education

to see . public

content

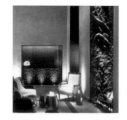

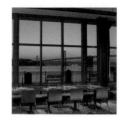

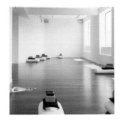

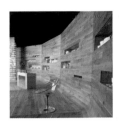

to go . wellness, beauty & sport

to shop . mall, retail, showrooms

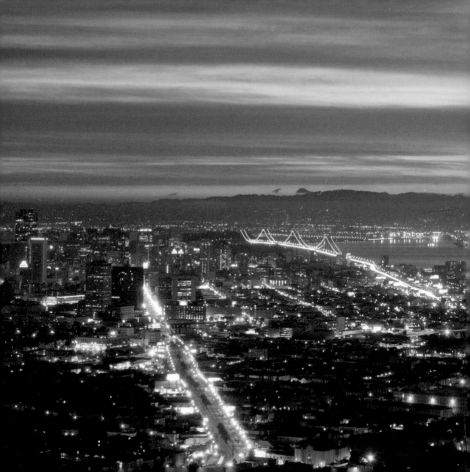

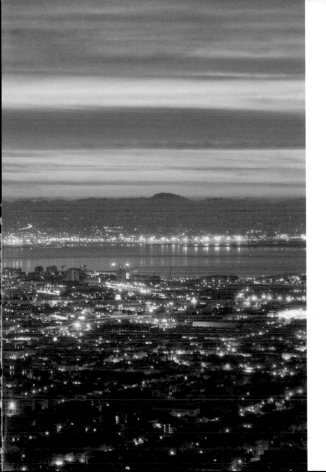

introduction

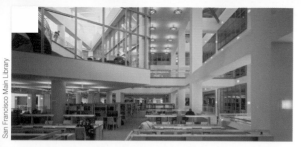

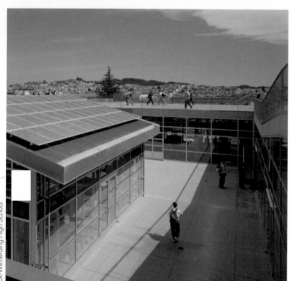

What is so inspiring about San Francisco? Is it that no one escapes awareness of the city's place in nature? The hills, bay and ocean demand attention to their presence by views from even the most grid-bound city streets. The Gold Rush brought dynamic, energetic people—from all over the world. The vibrant inner force kept flowing even after the earthquakes from 1906 and 1989 where the natural energy was then transmitted into a new urban wave. It was an awakening that reconciled the city with its own topography. The revitalized Ferry Building contributes to the rebirth of the city's historic water-front as other innovative projects; such as the San Francisco Main Library, The Lesbian Gay Bisexual Transgender Community Center and the de Young museum. These are great examples for the understanding of the cultural aesthetics and his-torically significant structures. With one of the most urbane, cosmopolitan cultures in America, San Francisco celebrates its singular style where Victorian and modernist architecture continue to collide.

Was ist an San Francisco so inspirierend? Ist es die besondere geografische Lage am Ozean mit der riesigen Naturbucht, den vielen grünen Hügeln, den steilen Straßen und ihren atemberaubenden Aussichten? Dieser Faszination kann man sich kaum entziehen. Schon der Goldrausch führte dynamische Menschen aus aller Welt in diese Stadt, deren pulsierende Kraft den beiden großen Erdbeben von 1906 und 1989 nicht nur widerstand, sondern neue Impulse für die Stadtentwicklung auslöste und dazu beitrug, urbane Architektur mit der Topographie in Einklang zu bringen. Einen Startschuss zur Wiederbelebung des historischen Hafens gab das umgebaute Ferry Building. Andere Projekte, wie die San Francisco Main Library, The Lesbian Gay Bisexual Transgender Community Center oder das de Young museum sind großartige Beispiele für das Verständnis kulturhistorischer Strukturen. Als eine der weltoffensten Städte in den USA feiert San Francisco heute wieder mehr denn je seine eigene Stilmischung, die viktorianische und moderne Architektur bestens miteinander verbindet.

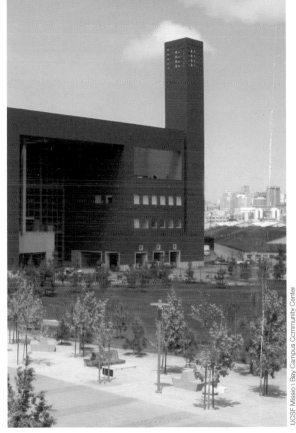

UCSF Mission Bay Campus Community Center

9

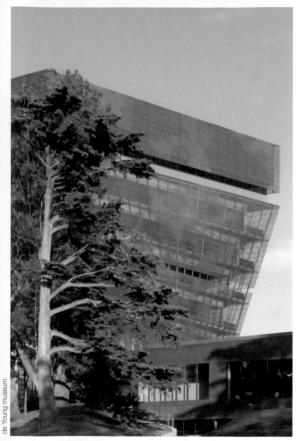

Qu'est-ce que San Francisco a de si inspirant ? Est-ce la situation géographique si particulière au bord d'une grande baie sur l'océan, entourée de collines vertes, avec ses rues en pente raide et ses panoramas grandioses ? Il est impossible de se soustraire à cette fascination. Jadis la fièvre de l'or a attiré des hommes dynamiques du monde entier dans cette ville dont l'énergie battante lui a permis de résister aux deux grands tremblements de terre de 1906 et 1989 et a en outre libéré de nouvelles impulsions pour le développement urbain, contribuant à réconcilier la ville avec sa topographie. La renaissance du port historique s'est traduite par la transformation du Ferry Building. D'autres projets, tels que la San Francisco Main Library, le Lesbian Gay Bisexual Transgender Community Center ou le de Young Museum sont de magnifiques exemples pour la compréhension des structures culturelles et historiquement importantes. San Francisco, l'une des villes les plus cosmopolites du monde, célèbre un style singulier qui allie architecture victorienne et moderne.

¿Qué es lo que resulta tan inspirador en San Francisco? ¿Será su excepcional situación geográfica? La fascinación surge sin duda ante calles en pendiente que abren sus vistas ineludibles a la imponente bahía natural, las verdes colinas y el océano. Ya la fiebre del oro se encargó de atraer a los más emprendedores de todo el mundo hacia esta ciudad; su vibrante energía no sucumbió ni siquiera a la enorme fuerza devastadora de los terremotos de 1906 y 1989, sino más bien al contrario, recibió un nuevo impulso para desarrollarse y armonizar la arquitectura urbana con la topografía del lugar. El toque de salida para revivir el puerto histórico lo dio la renovación del Ferry Building. Otros proyectos como la San Francisco Main Library, el Lesbian Gay Bisexual Transgender Community Center o el de Young museum son algunos ejemplos más de una visión reconciliadora sobre estructuras históricas y estéticas culturales. Como una de las ciudades más cosmopolitas de los Estados Unidos, San Francisco celebra hoy más que nunca una mezcla de estilos propia, la fusión entre arquitectura victoriana y modernista.

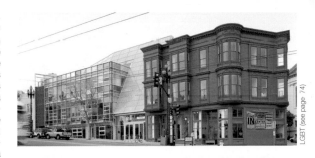

LGBT (see page 74)

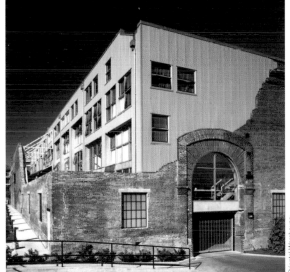

Oriental Warehouse

to see . living
office
culture & education
public

 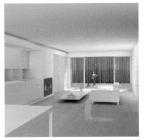 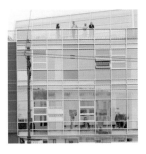

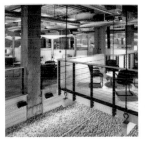 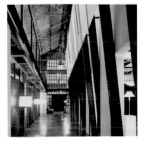

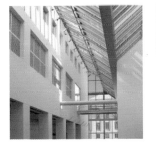 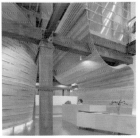 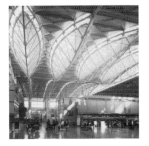

Park Presidio Residence

Kuth/Ranieri Architects
Byron Kuth, Elizabeth Ranieri, Rebecca Sharkey
Lang Engineering (SE)

2003
Presidio

www.kuthranieri.com

The client's extensive collection of contemporary photography informs this single-family residence and its varied programmatic parts and site condition. The façade adapts to this residential area with its curtain wall sheathed in translucent glass.

Der Charakter dieses Einfamilienwohnhauses, seine unterschiedlichen programmatischen Elemente und der landschaftliche Kontext sind von der umfangreichen Sammlung zeitgenössischer Fotokunst des Auftraggebers inspiriert. Die Fassade aus Klarglas fügt sich in die Wohngegend ein.

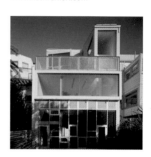

Le caractère de cette maison particulière avec ses différents éléments modulables a été façonné par l'importante collection de photographies modernes du client et le contexte paysager. La façade à rideau en verre translucide s'intègre dans le quartier résidentiel.

La extensa colección de fotografía contemporánea del dueño de la casa así como sus diversos elementos programáticos y el contexto paisajístico han moldeado el carácter de esta casa unifamiliar. La fachada de cortina de vidrio claro se adapta plenamente en esta zona residencial.

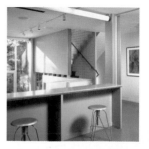

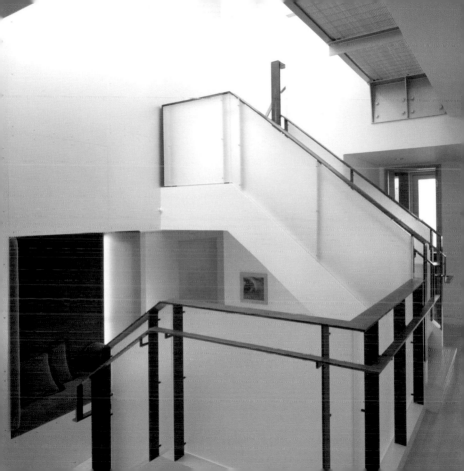

Martin Residence 3

Leddy Maytum Stacy Architects, William Leddy
Structural Design Engineers (SE)

1998
281 Chestnut Street
Telegraph Hill

www.lmsarch.com

The house, situated on a steeply inclined street on Telegraph Hill, has rare access to light and views on all four sides. Dramatic views of the 'City by the Bay' explain the thin site's desirable value and spatial design of parallel slots.

In dieses Wohnhaus in steiler Hanglage am Telegraph Hill fällt nur wenig Licht, aber es bietet Ausblick nach allen vier Seiten. Der eindrucksvolle Blick auf die San Francisco Bay erklärt, warum das schmale Grundstück so begehrt ist und für das Raumdesign die Aufteilung in parallele Teilstücke gewählt wurde.

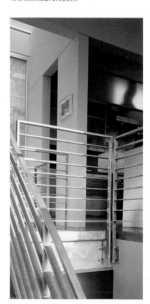

Cette demeure accrochée à la pente escarpée de la Telegraph Hill reçoit peu de lumière mais offre une perspective de tous les côtés. La vue spectaculaire sur la baie de San Francisco et le design privilégiant une répartition de l'espace en sections parallèles font de cet édifice un objet très convoité.

Esta vivienda ubicada en la pendiente escarpada de Telegraph Hill no es muy luminosa pero cuenta con vistas desde sus cuatro lados. Si algo convierte a este estrecho edificio en una joya es sin duda el maravilloso panorama que presenta a San Francisco Bay y el diseño de las estancias, que está caracterizado por secciones paralelas.

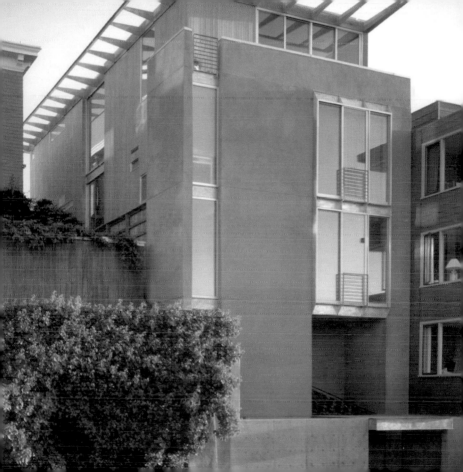

Shaw Residence

Stanley Saitowitz/Natoma Architects Inc.
Santos/Urrutia (SE)

2003
1110 Green Street
Russian Hill

www.saitowitz.com

This is how to make a five level renovation look like a three-story new build. An inverse arrangement of uses from bedrooms in the bay window below to living spaces above, put the living room windows at the top of Russian Hill with panoramic views.

So kann ein renoviertes fünfstöckiges Gebäude wie ein dreistöckiger Neubau aussehen. Die übliche Raumaufteilung wird ins Gegenteil verkehrt, die Schlafräume befinden sich im Erkerfenster und die Wohnräume darüber. Die Wohnzimmerfenster am höchsten Punkt des Gebäudes in Russian Hill bieten einen Panoramaausblick.

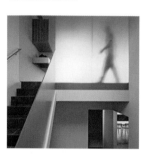

C'est ainsi qu'un bâtiment de cinq étages rénové peut avoir l'air d'une construction neuve de trois étages. Grâce à un agencement inversé des locaux, les chambres se trouvent dans les pièces avec fenêtre en encorbellement sous les pièces d'habitation situées au-dessus et les fenêtres de la salle de séjour de cette maison sur la Russian Hill offrent une vue panoramique.

Esta casa de Russian Hill muestra cómo un edificio renovado de cinco plantas puede parecer una construcción nueva de tres plantas. A través de una disposición inversa de las partes del edificio, los dormitorios han sido situados en la ventana del mirador, justo debajo de las salas de estar, dandole vistas panorámicas a las ventanas del salón.

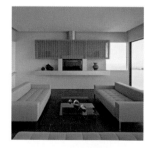

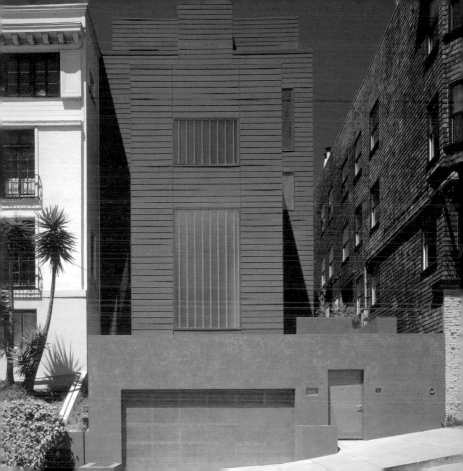

Iann/Stolz Residence

Kuth/Ranieri Architects
Byron Kuth, Elizabeth Ranieri
Teyssier Engineering (SE)

1999
Nob Hill

www.kuthranieri.com

The plans of each floor are organized to remain as open as possible to vistas from the city to the Golden Gate Bridge and beyond. The horizontal ledges and façade planar surface speaks about the orders of city, garden and building integrating in one single space.

Die Grundrisse der Stockwerke sind so angelegt, dass diese für Ausblicke über San Francisco bis zur Golden Gate Bridge und darüber hinaus möglichst offen bleiben. Die horizontalen Gesimse und die glatte Oberfläche der Fassade greifen die Struktur von Stadt, Garten und Gebäude auf. Alle Elemente verschmelzen zu einem großen Ganzen.

Le plan des étages est conçu de façon que ceux-ci soient aussi ouverts que possible sur le panorama de San Francisco jusqu'au Golden Gate Bridge et au-delà. La corniche horizontale et la surface lisse de la façade expriment les agencements de la ville, du jardin et de la maison qui se fondent dans un seul espace.

El esquema de distribución de las plantas está concebido de la forma más abierta posible para poder proporcionar vistas a San Francisco, incluso más allá del Golden Gate Bridge. Las cornisas horizontales y la superficie lisa de la fachada exteriorizan el ordenamiento de la ciudad, el jardín y los edificios, haciendo que parezcan fundirse en una sola estancia.

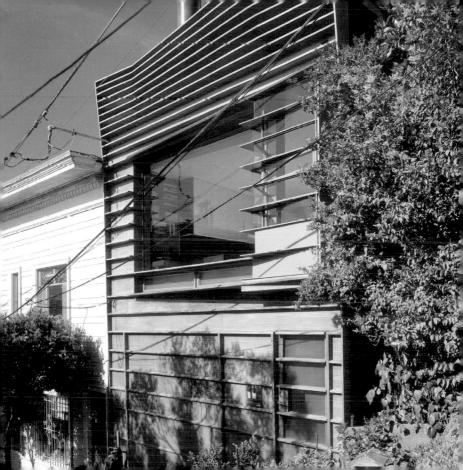

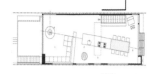

Haus Martin

CCS Architecture
GFDS Engineers (SE)
Ben Davies Construction (contractor)

2004
Buena Vista Park

www.ccs-architecture.com

Designed for a single European man, the living space is on the top floor with interiors of walnut and steel. The living room "fire-orb" with its excellent view to the ocean has become an iconic image in contemporary San Francisco architecture.

Dieses Penthouse mit Interieur aus Walnussholz und Stahl wurde speziell für einen alleinstehenden Europäer konzipiert. Das Wohnzimmer mit dem Hängekamin „Fire-Orb" bietet eine phantastische Aussicht auf den Pazifischen Ozean. In der zeitgenössischen Architektur von San Francisco hat es inzwischen Kultcharakter.

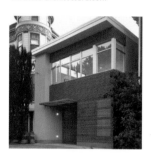

L'espace de vie conçu pour un célibataire européen se trouve au dernier étage ; l'intérieur est en noyer et en acier. La salle de séjour avec cheminée « Fire-Orb » et vue exceptionnelle sur l'océan pacifique est devenue entretemps un objet de culte dans l'architecture contemporaine de San Francisco.

Este espacio diseñado para un soltero europeo está ubicado en el último piso y cuenta con un interior en madera de nogal y acero. La chimenea "Fire-Orb" del salón y sus magníficas vistas al Océano Pacífico se ha convertido en un auténtico icono dentro del ámbito de la arquitectura contemporánea de San Francisco.

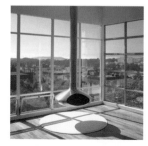

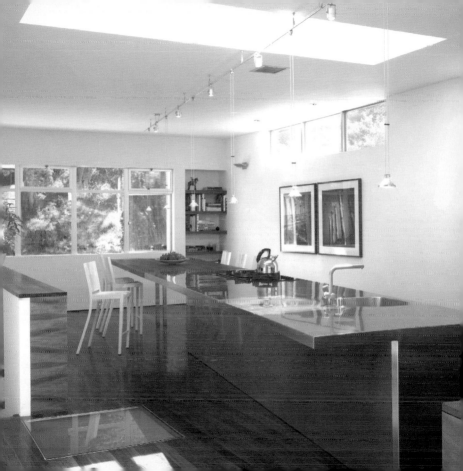

419 Fulton Street Housing

Pfau Architecture LTD
GFDS Engineers (SE)

2000
419 Fulton Street
Hayes Valley

www.pfauarchitecture.com

The Hayes Valley neighborhood has become the progressive home of the city's urban design agenda by tearing down expressways to build housing. This multi-unit residential loft uses a unique side yard court to join up existing outdoor spaces.

Hayes Valley zählt bei der urbanen Planung zu den progressiven Stadtteilen. Zur Gewinnung von neuem Wohnraum hat man hier die ehemaligen Schnellstraßen abgerissen. Das Gebäude mit zahlreichen Wohnlofts schließt mit einem originellen Seitenhof an die bestehenden umliegenden Gebäude an.

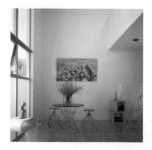

Le terrain occupé par d'anciennes autoroutes étant constructible, le quartier de Hayes Valley est devenu un lieu de progrès sur l'agenda du design urbain. Le loft qui comprend de nombreuses unités d'habitation exploite une cour latérale très originale pour s'intégrer aux espaces extérieurs existants.

El barrio de Hayes Valley se ha ido convirtiendo progresivamente en uno de los objetivos en la agenda del diseño urbanístico destruyendo autopistas para construir viviendas. El loft, que alberga gran cantidad de unidades habitables, aprovecha un único patio lateral para unirse a los espacios exteriores existentes.

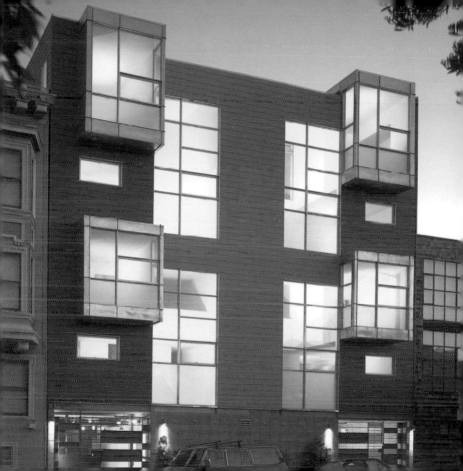

SOMA House

Jim Jennings Architecture
Santos/Urrutia (SE)

2002
967 Howard Street
Civic Center

www.jimjenningsarchitecture.com

An inward-looking courtyard house stands on a gritty 'South of Market' street. Its Cor-Ten steel façade is perforated to emit light to translucent glass screens. Jennings' empathy for the artistic enigma of refuge and urbanity is resolved in serene interiors.

Das nach innen gerichtete Hofgebäude steht an einer belebten Straße südlich der Market Street. Die Fassade aus Cor-Ten-Stahl ist durchbrochen, damit Licht durch die durchscheinenden Scheiben fallen kann. Einfühlsam schafft Jennings den künstlerischen Spagat zwischen Rückzugsbereich und Urbanität durch heitere Innenräume.

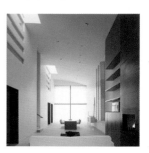

Ce bâtiment avec cour très introverti se trouve sur une rue animée au sud de Market Street. Sa façade d'acier Corten est perforée pour faire passer de la luminosité au travers des vitres de verre translucide. Grâce à son empathie, Jennings résout l'antagonisme artistique entre sphère privée et urbanité par la sérénité des intérieurs.

Esta transpuesta de carácter introvertido se ubica en una agitada calle al sur de Market Street. La fachada de acero Cor-Ten está perforada con el fin de irradiar la claridad a través de las ventanas de vidrio claro. Jennings ha conseguido resolver a través de interiores serenos el enigma artístico que se crea entre los espacios íntimos y el urbanismo.

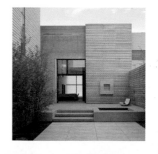

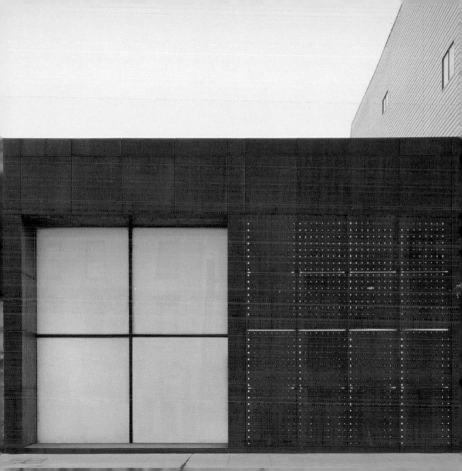

1028 + 1022 Natoma Street

Stanley Saitowitz/Natoma Architects Inc.
Santos/Urrutia (SE)

2005 + 1991
1028 + 1022 Natoma Street
South of Market

www.saitowitz.com

The on-off façade of this pair of typical South of Market infill sites is a decidedly untypical design of the mute and the spoken. Built 14 years apart from each other and responding in a similar way to its site, 1022 has a five foot service zone at the party wall paired with a 15 foot living zone of freely supported space.

Die vorgehängten Fassaden dieser beiden für South of Market typischen Füllbauten fallen durch ihr markantes Design auf. Die Gebäude wurden im Abstand von 14 Jahren errichtet, gehen aber in ähnlicher Weise auf ihre Umgebung ein. In die Seitenwände von 1022 Natoma Street ist eine 1,5 Meter Service-Zone integriert, kombiniert mit 4,5 Metern freitragendem Wohnraum.

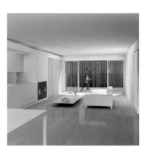

Les façades rideaux de ces maisons jumelles dans un quartier typique de South of Market affichent un design atypique. Construites à 14 ans d'intervalle elles réagissent pareillement à leur environnement ; les parois latérales du 1022 Natoma Street intègrent une zone technique de 1,5 m, combinée à un espace indépendant de 4,5 m.

La fachada que se prende y desprende de este par de edificios en un emplazamiento típico de 'South of Market', es un diseño atípico. Construidos 14 años aparte ambos reaccionan similarmente ante su entorno. El 1022 con paredes laterales tiene un area de servicio de 1,5 metros unida a un espacio de 4,5 metros libre.

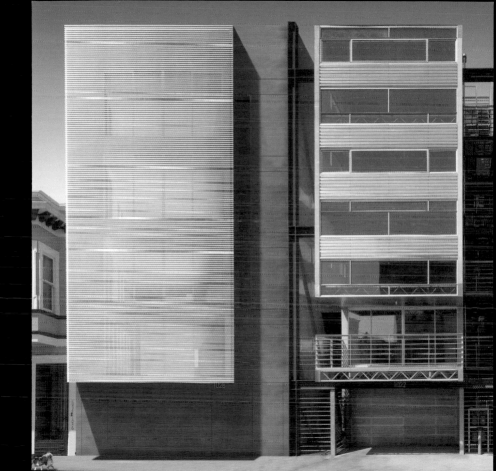

251 South Van Ness

Pfau Architecture LTD
Murphy Burr, Curry, Inc. (SE)

2003
251 South Van Ness Avenue
South of Market

www.pfauarchitecture.com

The house-like quality of this office/studio/design firm is the lifelong dream of the married couple who commissioned it as a 'total workplace' for living with their various businesses. Studios are oriented to north light along the alley.

In diesem Gebäude hat ein Ehepaar seinen Traum von Wohnen und Arbeiten verwirklicht. Auftrag an die Planer war es, Räume zu kreieren, die sämtliche Lebensbereiche und Tätigkeiten unter einem Dach vereinen. Die Studios liegen parallel zur Straße, der Lichteinfall erfolgt aus nördlicher Richtung.

Ce mélange de Bureau/Studio/ Agence de design ressemblant à une demeure est le rêve d'une vie d'un couple marié qui avait commandé une « total workplace » pour y vivre en harmonie avec leurs multiples activités. Les studios donnent sur la rue, la source de lumière vient du nord.

La fusión entre oficina, estudio y empresa de diseño con calidad de vivienda era el sueño de un matrimonio que encargó la construcción del edificio como lugar de "trabajo absoluto", a fin de vivir en plena armonía con sus diversas actividades. Los estudios dan a la calle y reciben luz del norte.

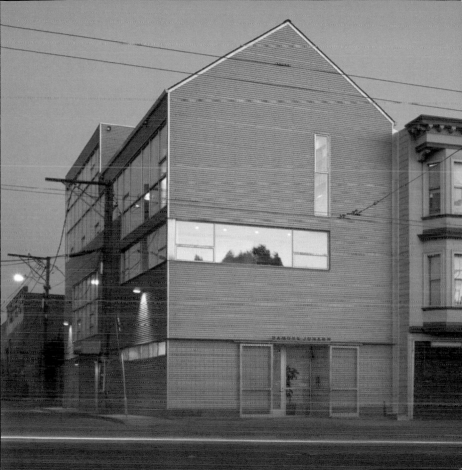

Folsom Dore Apartments

David Baker + Partners
OLMM Consulting Engineers (SE)

2005
75 Dore Street
South of Market

www.dbarchitect.com

Folsom Dore is the first affordable development to be considered for LEED (Leadership in Energy and Environmental Design) certification. It provides shared parking for the community and a historic storefront space to 98 units for the chronically homeless and unemployed with HIV/AIDS, and others on low incomes.

Folsom Dore ist das erste erschwingliche Beispiel mit möglicher LEED Zertifizierung (Leadership in Energy and Environmental Design). Mit Parkmöglichkeiten für die Hausgemeinschaft und einer historischen Ladenzeile bietet das Gebäude 98 Wohneinheiten für dauerhaft Obdachlose, Langzeitarbeitslose, HIV-AIDS-Patienten und andere Menschen mit niedrigem Einkommen.

Folsom Dore est la première solution abordable homologable par LEED (Leadership in Energy and Environmental Design). Avec des places de parking pour la communauté et une rangée historique de magasins, le bâtiment propose 98 appartements pour des sans-abri, chômeurs, séropositifs ou malades du VIH/SIDA et autres locataires à faible revenu.

Folsom Dore es la primera solución asequible que se ajusta al criterio LEED (Leadership in Energy and Environmental Design). El edificio cuenta con aparcamiento común para la comunidad de vecinos, un frontal de local histórico y alberga 98 viviendas para indigentes y desempleados, con SIDA o VIH y personas con salario bajo.

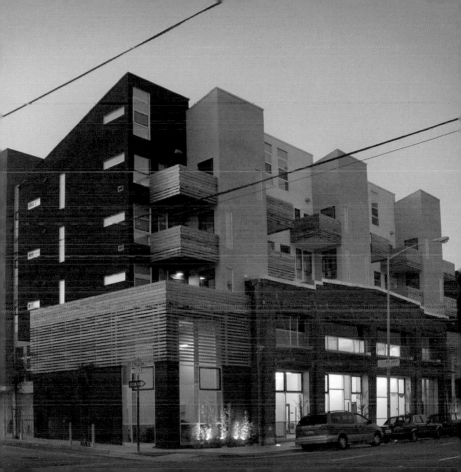

8th + Howard Apartments + SOMA Studios

David Baker + Partners
I A Gonzales Architects
Faye Bernstein & Associates (SE)

2003
1180–90 Howard Street
South of Market

www.dbarchitect.com

An example of the best in affordable housing: 74 family units, 88 studios, childcare center, parking and the hugely successful 'Harvest Market', all entered through a well-designed, modern green space that is the envy of market rate city dwellers.

Ein Musterbeispiel für erschwingliches Wohnen: 74 familiengerechte Wohneinheiten, 88 Studios, Kinderbetreuungseinrichtungen, Parkmöglichkeiten und der erfolgreiche „Harvest Market". Der Zugang erfolgt über eine attraktiv gestaltete Grünanlage. Ein Neidobjekt all derer, die zu marktüblichen Konditionen in der Stadt wohnen.

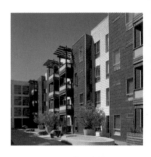

Voici un des meilleurs exemples pour un habitat abordable: 74 unités familiales, 88 studios, des équipements pour la garde des enfants, des parkings et le « Harvest Market » prospère – le tout accessible par l'intermédiaire d'un parc moderne bien dessiné, qu'envient les citadins soumis aux loyers du marché.

Es uno de los mejores ejemplos del saber vivir en una vivienda asequible: 74 pisos, 88 estudios, guardería, aparcamientos, y el frecuentado "Harvest Market". Todo ello dentro de una zona verde de diseño moderno que se ha convertido en la envidia de quienes viven en el centro a precios de mercado estándar.

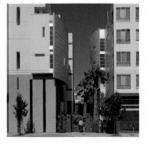

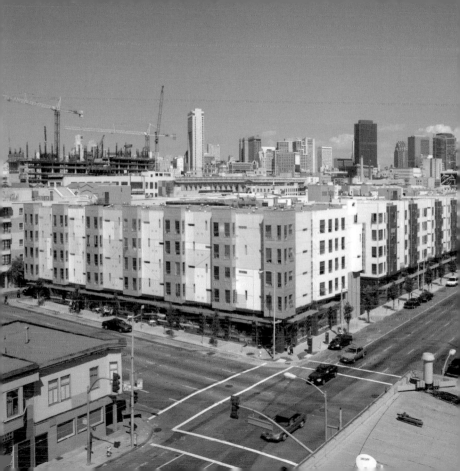

85 Natoma

Jim Jennings Architecture
Santos/Urrutia (SE)

2002
85 Natoma Street
South of Market

www.jimjenningsarchitecture.com

Counterplay between the curved roof form and the proud rectilinear bay form the primary street declaration in this transitional neighborhood. The impact of this large residential infill project is ameliorated with a single design gesture.

Das Wechselspiel zwischen der geschwungenen Dachform und der geradlinigen Erkerform stellt eine klare Aussage in der im Wandel begriffenen Wohngegend dar. Die Wirkung dieses großen, in einer Baulücke errichteten Projekts wird durch sein ausdrucksstarkes Design noch verstärkt.

L'alternance d'une partie arrondie et d'une partie en saillie aux lignes droites et fières est très expressive dans un quartier résidentiel en pleine mutation. L'impact de ce grand projet intercalaire est rehaussé par son design singulier et pertinent.

El juego de contrastes entre el tejado curvo y el soberbio frontal mirador de líneas rectas se reafirma en una zona residencial en transición. El impacto de este amplio proyecto llevado a cabo en un solar se acentúa gracias a un diseño único y cargado de expresión.

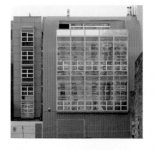

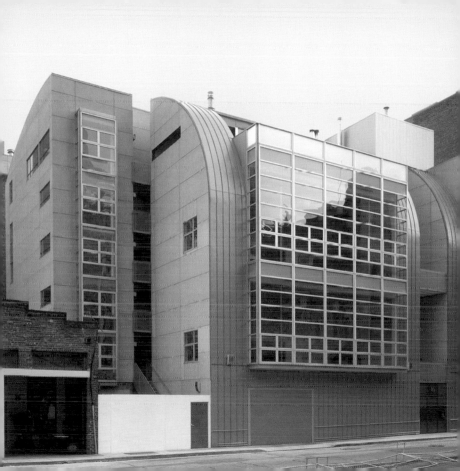

Yerba Buena Lofts

Stanley Saitowitz/Natoma Architects Inc.
Watry Design Group (SE)

2001
855 Folsom Street
South of Market

www.saitowitz.com

Yerba Buena is the paradigm of loft concepts. Despite the vagaries of fast-track construction, the 200 units with their impressive, popping bays of glass, concrete and double story heights, still set the bar by which loft designs are measured.

Yerba Buena besitzt Modellcharakter für das Konzept Loft. Trotz der Unwägbarkeiten bei beschleunigter Bauweise setzen die 200 Einheiten mit ihren hervortretenden zweistöckigen Erkern aus Glas und Beton einen Maßstab, an dem sich Loft-Design künftig messen lassen muss.

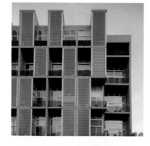

Yerba Buena est l'illustration type du concept de loft. Malgré leur caractère de constructions éphémères, avec leurs cubes en saillie sur deux étages, en verre et en béton, ces 200 unités sont un jalon sur l'échelle de mesure sur laquelle le design des lofts sera jaugé à l'avenir.

Yerba Buena es un paradigma del concepto de loft. A pesar de la visión que se les suele otorgar a éstos de construcciones pasajeras, estas 200 viviendas con su impresionante mirador saliente de vidrio y hormigón que abarca dos plantas, han pasado a ser el listón que mida el diseño de lofts en el futuro.

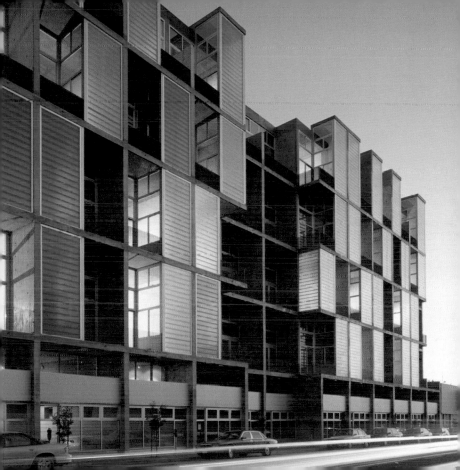

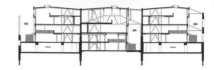

Oriental Warehouse

Fisher Friedman Associates
Peter Culley & Associates (SE)

1997
650 Delancey Street
South Beach

www.fisherfriedman.com

What is now a classic South Beach South of Market loft of contemporary live/work units was historically unique as the 125-year-old Oriental Warehouse. The building was originally an embarkation point for Asian immigrants.

Aus dem historisch einzigartigen und 125-Jahre alten Oriental Warehouse wurde ein klassisches South Beach-Loft südlich der Market Street mit zeitgemäßen Wohn- und Arbeitseinheiten. Ursprünglich diente das Gebäude asiatischen Immigranten als Anlaufstelle.

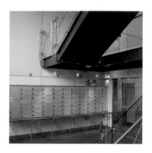

Ce qui jadis était un entrepôt oriental historiquement unique et vieux de 125 ans, est désormais un loft classique de South Beach au sud de Market Street, associant espace de vie et de travail. A l'origine, le bâtiment servait de point de chute aux immigrants asiatiques.

Con sus 125 años, lo que en su día fue la histórica y única Oriental Warehouse, se ha convertido hoy en un clásico South Beach South of Market loft de unidades de vivir y trabajar contemporáneas. Originalmente este edificio servia de puerto de embarque para inmigrantes asiáticos.

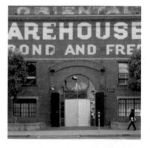

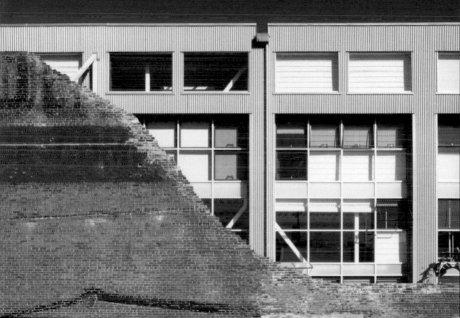

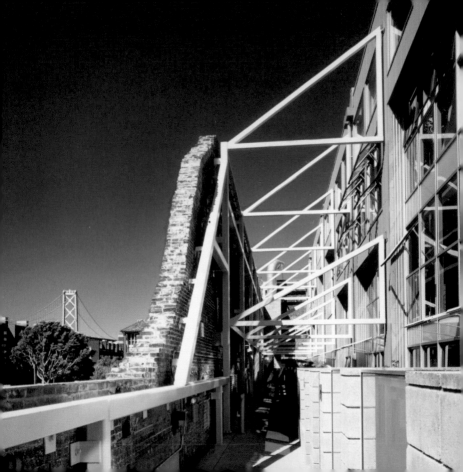

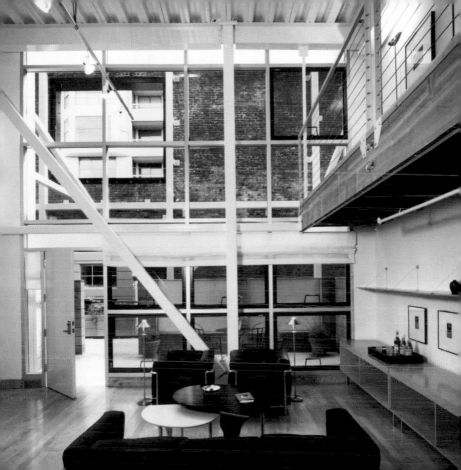

2002 Third Street

Stanley Saitowitz/Natoma Architects Inc.
Santos/Urrutia (SE)

2002
2002 3rd Street
Potrero Hill

www.saitowitz.com

One of the larger live and work neighborhoods in the city, this lower Potrero site is adjacent to the new University of California Mission Bay Campus and it is near the California College of the Arts. The infill building contains 38 live/work loft style units.

Dieses Gebäude in Lower Potrero, einer der größeren Wohn- und Geschäftsgegenden San Franciscos, grenzt an den Mission-Bay-Campus der University of California und liegt in der Nähe des California College of the Arts. Das in einer Gebäudelücke errichtete Bauwerk umfasst 38 loftartige Wohn- und Geschäftseinheiten.

Ce bâtiment situé dans l'un des quartiers d'affaires et résidentiels assez importants de San Francisco à Lower Potrero est proche du campus Mission Bay de l'université de Californie et voisine avec le California College of Art. La construction réalisée sur un terrain intermédiaire comprend 38 unités d'habitation et d'affaires de type loft.

Situado en una de las zonas de viviendas y actividad laboral más grande de San Francisco el edificio inferiormente ubicado en Potrero limita con el campus de la University of California Mission Bay y está cercano al California College of Art. La construcción llevada a cabo en el solar alberga 38 elementos tipo loft a modo de viviendas y oficinas.

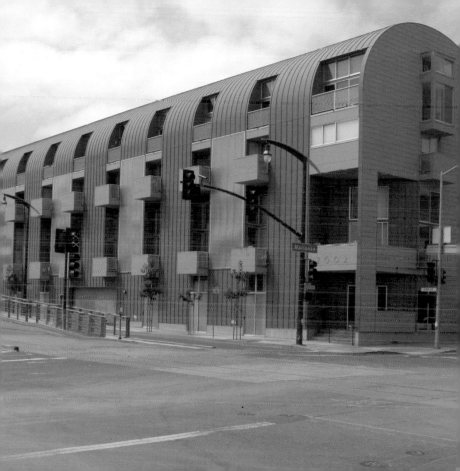

TBWA\Chiat\Day

Marmol Radziner and Associates
Tipping Mar + Associates (SE)

2001
55 Union Street
Telegraph Hill

www.tbwachiat.com
www.marmol-radziner.com

By stripping the building down to its' brick walls, wood ceilings, timber columns and large glass windows, the space and access to natural light were significantly improved; adding custom furniture and wood slat wall forms finish off the relaxed space.

Durch die Reduzierung auf Backsteinmauern, Holzdecken, Balken und großflächige Glasfenster wurden der Raum und der natürliche Lichteinfall in diesem Gebäude optimiert; maßgefertigte Möbel und Wandformen aus Holzleisten geben dem entspannten Raumgefühl den letzten Schliff.

En réduisant le bâtiment à ses murs de brique, plafonds de bois, poutres et baies vitrées, on a optimisé l'espace et la source de lumière naturelle ; des meubles taillés sur mesure et des murs formés avec des lamelles en bois parachèvent l'ambiance détendue régnant dans cet espace.

El edificio ha sido reducido a sus paredes de ladrillo, techos de madera, vigas y ventanales para optimizar así la entrada de luz natural. El toque final lo aportan los muebles a medida y revestimientos de madera con listones, que crean espacios relajantes.

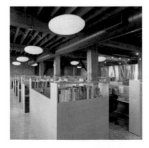

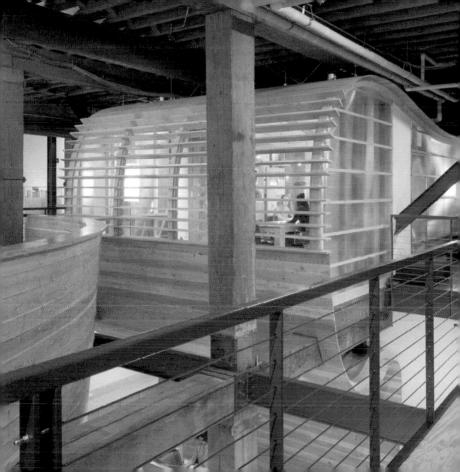

Stone & Youngberg, LLC

STUDIOS Architecture
Rutherford & Chekene (SE)

2003
The Ferry Building
The Embarcadero

www.styo.com
www.studiosarch.com

Studios Architecture assisted their investment banking firm client with site evaluation and selection of the historic, renovated Ferry Building. The new interior juxtaposes modern forms in a dramatic historic casing emphasizing details and systems.

Studios Architecture unterstützte seinen Kunden, eine Firma für Investment Banking, bei der Bewertung und schließlich der Wahl des historischen renovierten Ferry Buildings als Standort. Im neuen Interieur fügen sich moderne Formen in ein spannungsreiches historisches Gerüst ein und betonen Details und Installationen.

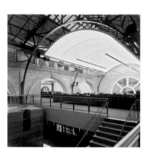

Studios Architecture a conseillé son client, une société d'investissement bancaire, dans l'évaluation et le choix du terminal des ferries historique rénové. Le nouvel intérieur applique des formes modernes dans un bâtiment historique spectaculaire et met en valeur les installations et les détails.

Studios Architecture prestó apoyo a su cliente, una empresa de banca de inversión, en la evaluación y elección del histórico, renovado Ferry Building. El nuevo interior integra formas modernas en un esqueleto histórico escénico, dando énfasis a las instalaciones y a los detalles.

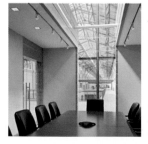

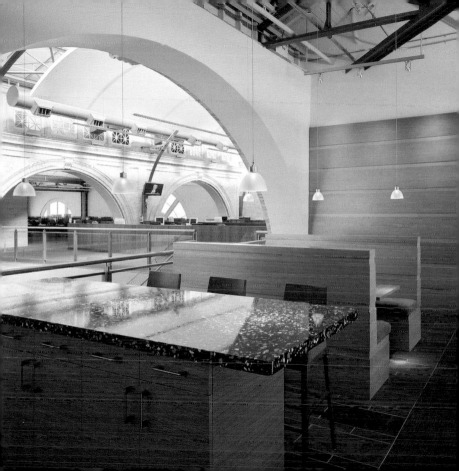

150 California Street

HOK
Middlebrook + Louie (SE)

1999
150 California Street
Financial District

www.hok.com

A 23-story tower that complies with the city's sunlight conservation angles and historic preservation ordinances by cutting back the stepped tower and thereby 'playing nicely' with some very large modern towers as neighbors.

Das 23-stöckige Gebäude erfüllt durch den sich stufenweise verjüngenden Turm die städtischen Verordnungen zum Erhalt des Tageslichteinfalls sowie des Denkmalschutzes und behauptet sich neben den mächtigen, modernen umstehenden Gebäuden.

Le bâtiment de 23 étages respecte, grâce au retrait par paliers de la tour, les règlements d'urbanisme concernant la préservation de la lumière du soleil ainsi que les règlements sur la protection des monuments. Il fait ainsi jeu égal avec les grands immeubles modernes et imposants de son entourage.

El edificio de 23 plantas se ajusta a la normativa estatal de conservación del reglamento de preservación historica y a la de no restar luz a los bloques colindantes, a través de una estructura de terrazas escalonadas, que crea un juego de estructuras con los impactantes edificios modernos que le rodean.

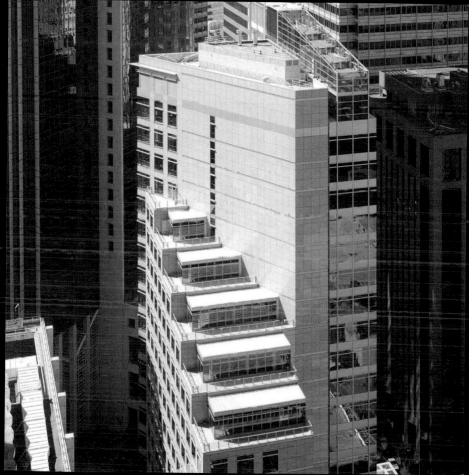

Cahan & Associates

Jensen & Macy Architects
Murphy Burr, Curry, Inc. (SE)

2001
171 2nd Street
South of Market

www.cahanassociates.com
www.jensen-macy.com

A clever renovation of the top two floors of early 20th century six-story building for a graphic design firm, exposing existing brick and concrete combined with a simple new palette of walnut, steel, glass and drywall.

Eine clevere Renovierung der beiden obersten Stockwerke eines sechsstöckigen Gebäudes aus dem frühen 20. Jahrhundert im Auftrag einer Graphikdesignfirma: Bei der Renovierung wurden Beton und Backstein freigelegt und mit einer Bandbreite schlichter neuer Materialien – Walnussholz, Stahl, Glas und Gipskarton – kombiniert.

Voici une habile rénovation des deux étages supérieurs d'un bâtiment de six étages datant du début du 20ème siècle, commandée par une agence de design et de graphisme, mettant au jour la brique et le béton existants pour les combiner avec une palette simple de matériaux nouveaux tels que le noyer, l'acier, le verre et le placoplâtre.

Una renovación inteligente de los dos últimos pisos de un edificio de principios del siglo XX con seis plantas, encargo de una empresa de diseño gráfico. En ella se han dejado al descubierto ladrillo y hormigón, combinándolos con una gama sobria de materiales como la madera de nogal, vidrio, acero y pladur.

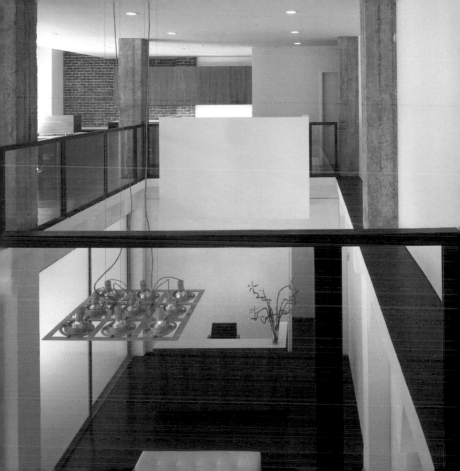

Foundry Square

STUDIOS Architecture
Jim Jennings Architecture (Consulting Architect)
Nishkian Menninger (SE)

2003
Building 2: 405 Howard Street
Building 4: 500 Howard Street
South of Market

www.studiosarch.com
www.jimjenningsarchitecture.com

The sustainable design, expressive, playful forms and variable floor plate sizes delight everyone, from businessman to artist. This master plan is a new landmark office complex in downtown San Francisco.

Das nachhaltige Design, die ausdrucksstarken und verspielten Formen sowie die variable Größe der Bodenplatten versetzen jeden vom Geschäftsmann bis zum Künstler in Begeisterung. Der Masterplan ist ein Meilenstein unter den Bürokomplexen in Downtown San Francisco.

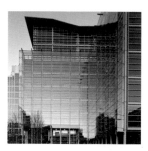

Le design précurseur, les formes aussi expressives qu'espiègles ainsi que la dimension variable des dalles enthousiasment chacun, du businessman à l'artiste. Le plan maître est une référence parmi les complexes de bureaux situés downtown San Francisco.

Un diseño capaz de su sostenibilidad de formas expresivas y caprichosas y enlosados de diferentes medidas que cautivan tanto al hombre de negocios como al artista. Esta obra magistral es un verdadero hito dentro los edificios de oficinas del centro de San Francisco.

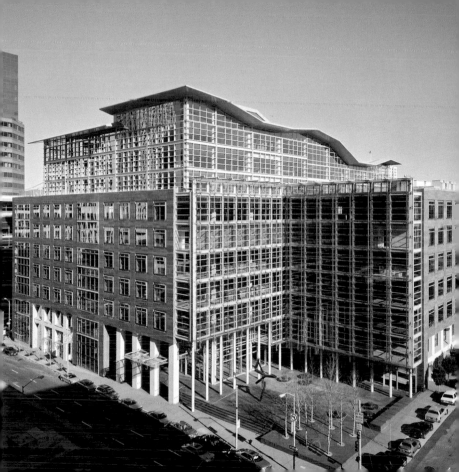

Boyd Lighting Company

Brayton + Hughes Design Studio

1998
944 Folsom Street
South of Market

www.boydlighting.com
www.bhdstudios.com

What was an old factory space, is now a daylight filled showroom and office for the Boyd Lighting Company. Roof sky lighting, display lighting and a well-lit façade that glows at night, contribute to the award-winning design.

Früher ein altes Fabrikgebäude, heute lichtdurchfluteter Showroom und Büro der Boyd Lighting Company. Fensteroberlichte und Lichtdisplays, sowie eine gut erhellte, nachts leuchtende Fassade sind wichtige Elemente des preisgekrönten Designs.

Ce qui était autrefois une ancienne usine abrite aujourd'hui une salle d'exposition inondée de lumière ainsi que les bureaux de la Boyd Lighting Company. Des impostes, des appliques lumineuses et une façade bien illuminée qui brille dans la nuit ont contribué au design souvent primé.

Lo que en el pasado fue una vieja fábrica alberga hoy una luminosa sala de exposición y las oficinas de la Boyd Lighting Company. Claraboyas, pantallas de luz y una fachada clara que brilla por la noche han contribuido a este diseño que ya ha sido galardonado.

frog design

David Baker + Partners
John Yadegar & Associates (SE)

1998
420 Bryant Street
South of Market

www.frogdesign.com
www.dbarchitect.com

This project is a renovated warehouse for an international industrial design office. A number of curved elements is contrasted with the existing structural grid: a large arc of velvet curtain, walls of fiberglass and recycled fiberboard.

Das Objekt war ursprünglich ein Lagerhaus, das für ein internationales Industriedesignbüro renoviert wurde. Einige geschwungene Elemente kontrastieren mit der bereits existierenden Gitterstruktur: ein Samtvorhang in Form eines ausladenden Bogens, Fiberglaswände und Recyclingfaserplatten.

Entrepôt à l'origine, ce bâtiment a été rénové pour une agence internationale de design industriel. Quelques éléments courbes contrastent avec la grille de structure existante : un ample rideau de velours en arc de cercle, des parois en fibre de verre et des panneaux en fibres recyclées.

En un principio se trataba de un almacén que fue renovado para una empresa internacional de diseño industrial. En contraste con la estructura reticular existente se han insertado elementos curvados, tales como una cortina de terciopelo en forma de arco, ventanas de fibra de vidrio y planchas de fibra recicladas.

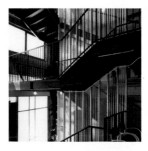

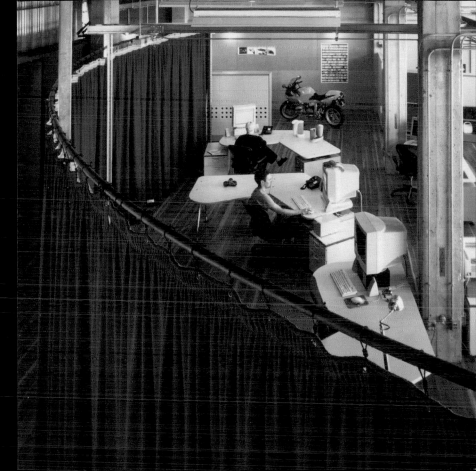

San Francisco
MultiMedia Center

Pfau Architecture LTD
Tipping Mar + Associates (SE)

2000
475 Brannan Street
South of Market

www.pfauarchitecture.com

The experience of the building speculates on the digital worldview of its inhabitants with an interactive lobby "media wall" and "digital courtyard landscapes". The result is a constantly changing spatial and material play between existing and new.

Bei diesem Gebäude wird in Gestalt der interaktiven, mit einer „Multimediawand" ausgestatteten Lobby und der „digitalen Innenhoflandschaften" auf die digitale Weltsicht der Bewohner angespielt. Ergebnis: ein in ständigem Wechsel begriffenes Spiel von Raum und Materie, zwischen Alt und Neu.

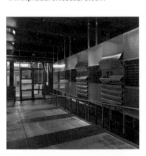

Expérimenter le bâtiment avec son lobby interactif pourvu d'un mur multimédia et de paysages de cours intérieures numériques n'autorise que des suppositions sur la vision du monde numérique de ses habitants. Le résultat en est un jeu d'espace et de matériau en perpétuel changement entre le réel et le nouveau.

La impresión que causa vivir el edificio a través de una pantalla multimedia instalada en el vestíbulo y los "paisajes digitales" del patio interior, dejan especular sobre la visión digital del mundo que tienen sus habitantes. El resultado es un constante juego cambiante entre el espacio y el material, entre lo antiguo y lo nuevo.

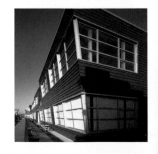

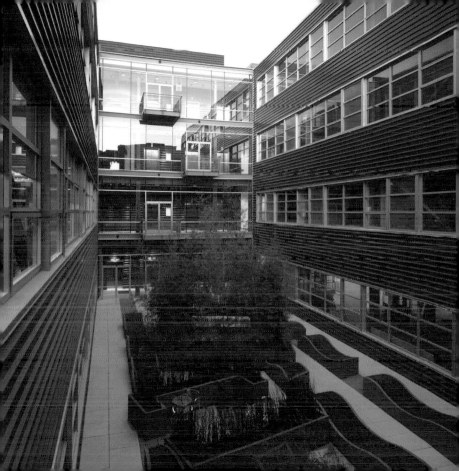

Former E*Trade 123

Townsend Offices

STUDIOS Architecture
GFDS Engineers (SE)

2001
South of Market

www.studiosarch.com

An old coffee warehouse becomes a new electronic securities trading office for E*trade Financial, holding eight office floors connected by a central roof-lit atrium, a cafe open to the public for trading and 'touch down' offices for traveling managers.

Ein altes Lagerhaus für Kaffee wird zu einem neuen Büro für elektronischen Wertpapierhandel der Firma E*trade Financial mit acht durch einen zentralen Lichthof verbundenen Büroebenen. Mit dazu gehören ein öffentliches Café für Kundengeschäfte und Büros, die auswärtigen Managern zur Verfügung gestellt werden.

Un vieil entrepôt à café devient le nouveau bureau pour le commerce électronique de titres de la société E*trade Financial qui comporte huit niveaux reliés par un atrium central vitré ainsi qu'un café public destiné aux clients et des bureaux à la disposition d'hommes d'affaires en voyage.

Un antiguo almacén de café se transforma en una nueva oficina de comercio electrónico de acciones perteneciente a la empresa E*trade Financial, que cuenta con ocho plantas de oficinas comunicadas a través de un patio de luces. A ello se une una cafetería para los negocios de clientes y oficinas para manager en viaje de negocios.

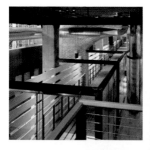

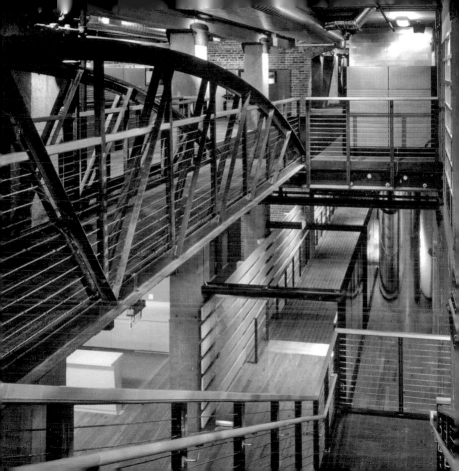

550 Terry Francois Street

Mission Bay Block 28

STUDIOS Architecture
Nabih Youssef & Associates (SE)
Faye Bernstein & Associates (SE)

2002
550 Terry Francois Street
Mission Bay

www.studiosarch.com

One of the first designs in the huge 315 acre Mission Bay train yards and docklands redevelopment. This 30,000 sq. ft. is designed as if it were two separate buildings with one rectangular six-story wing and a curved five-story annex recalling warehouse lofts.

Eines der ersten Projekte auf dem riesigen, fast 130 ha großen Gelände des Rangierbahnhofs von Mission Bay und der sanierten Docks. Dieses fast 2800 m² große Gebäude wurde so entworfen, als wären es zwei separate Gebäude: ein rechtwinkliger, sechsstöckiger Flügel und ein geschwungener, fünfstöckiger Annex, der an Lagerhallen-Lofts erinnert.

Un des premiers projets sur l'immense terrain de quelque 130 ha de la gare de triage Mission Bay et des docks réhabilités. Ce bâtiment de presque 2800 m² a été conçu comme s'il s'agissait de deux immeubles séparés : une aile rectangulaire de six étages et une annexe arrondie de cinq étages qui rappelle les lofts construits à partir d'entrepôts.

Uno de los primeros diseños en el vasto recinto de casi 130 hectáreas de áreas del tren de Mission Bay y sus dársenas rehabilitadas. Este espacio de unos 2800 m² fue esbozado para asemejar dos edificios separados: un ala rectangular de seis plantas y un anexo curvo de cinco pisos recordando a los lofts tipo almacén.

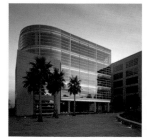

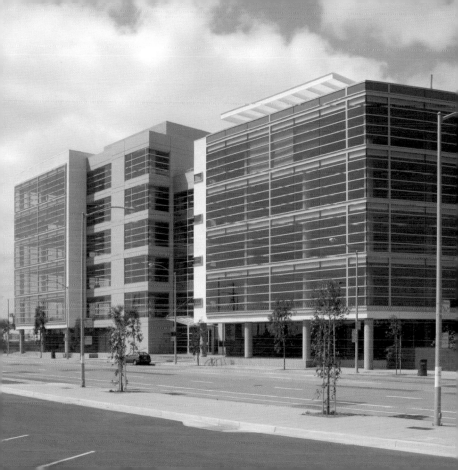

350 Rhode Island

Pfau Architecture LTD/Chong Partners Architecture
Forell/Elsesser Engineers, Inc. (SE)

2002
350 Rhode Island Street
Potrero Hill

www.pfauarchitecture.com

This multimedia/information technology office attempts to humanize the typical urban office space with the use of light and materials. A fundamental precast concrete system with wooden louvers and translucent panels embedded in the exterior wall skin allow the exploration. Sky-lit interiors add to the subtle modulation.

Die Büroräume der Multimedia- und IT-Firma wurden durch Licht und Materialien ansprechender gestaltet. Dafür sorgt ein auf einem Fertigbetonsystem basierender Arbeitsbereich mit in die Außenwände eingebetteten Holzblenden und durchsichtigen Paneelen. Die mit Fensteroberlichten ausgestatteten Innenräume runden die Gestaltung ab.

Ce bureau dédié aux technologies de l'information et au multimédia tente d'humaniser l'espace urbain typique de bureaux au moyen de la lumière et des matériaux, mettant en œuvre un système de béton préfabriqué avec des volets de bois incorporés à l'extérieur et des panneaux translucides. Les imposantes des espaces intérieurs parachèvent le concept.

Esta oficina de multimedia y tecnología informática intenta humanizar el típico espacio de oficinas urbanas por medio de luz y materiales. La exploración es a través de un sistema de hormigón prefabricado con marcos de madera encastrados en el exterior y paneles transparentes. Los tragaluces añaden a la modulación.

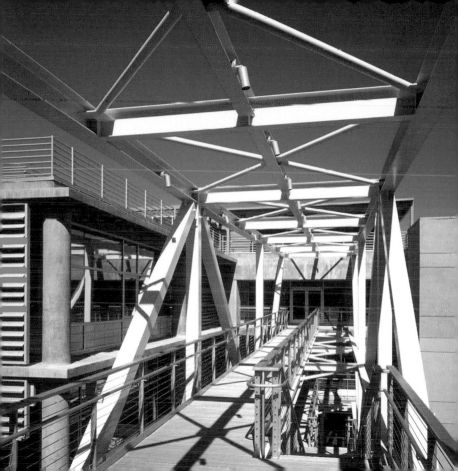

de Young museum

Herzog & de Meuron
Fong & Chan Architects
Walter Hood (Landscape Architect)
Rutherford & Chekene (SE)

2005
50 Tea Garden Drive
Golden Gate Park

www.thinker.org
www.fca-arch.com

The perforated copper façade mimics dappled light filtering through trees creating an a stract pattern. Reducing the museum's footprint by 37% and returning two acres of open space to the Golden Gate Park allow park visitors glimpses of the art and provides museumgoers with panoramic views of the landscape.

Die perforierte Kupferfassade erzeugt ein Schattenmuster wie unter einem Laubdach. Die Grundfläche wurde um 37% reduziert und mehr als 8000 m² freie Fläche dem Golden Gate Park zurückgegeben. So kann der Parkbesucher Blicke auf die Kunstwerke erhaschen und der Museumsbesucher den Panoramablick über die Landschaft genießen.

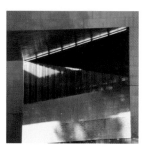

Les reflets de la façade de cuivre perforée rappellent les rayons du soleil filtrés par les arbres créent des dessins abstraits. La surface de base ayant été réduite de 37% et plus de 8000 m² ayant été rendus au parc du Golden Gate, le promeneur du parc peut lancer ses regards sur les œuvres d'art et le visiteur du musée peut apprécier le site.

La fachada perforada de cobre simula filtros de luz cayendo por los árboles creando un relieve abstracto. La superficie ha sido reducida en un 37% y más de 8000 m² de extensión exterior han sido devueltos al Golden Gate Park, asi los visitantes del parque vislumbran las obras de arte y los del museo son dotados con vistas panorámicas.

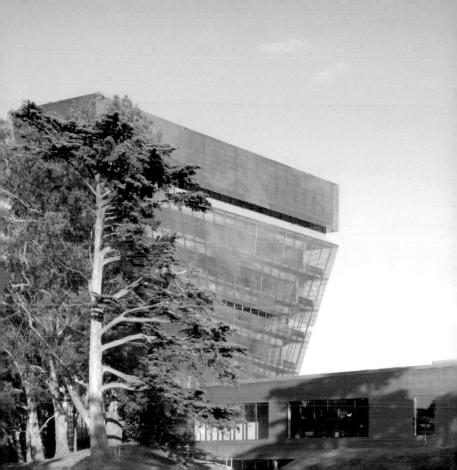

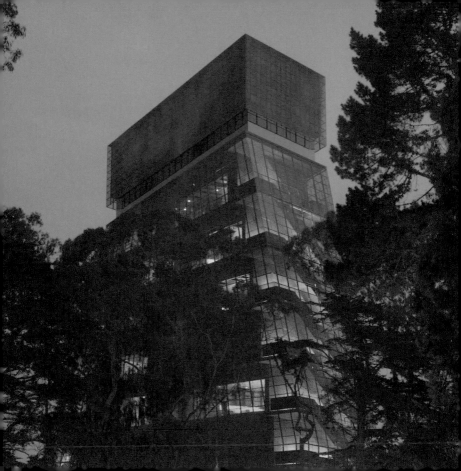

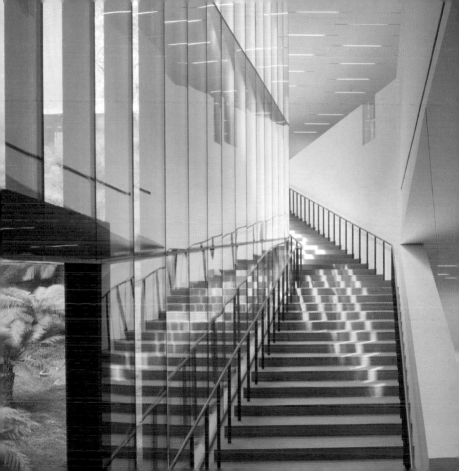

University of California, San Francisco (UCSF)

Parnassus Campus

Fougeron Architecture

to be determined
500 Parnassus Avenue
Parnassus

www.fougeron.com

The redesigning of the two-story space introduces a series of wood and glass planes held together within a steel frame; all pieces are prefabricated and built off-site. This new system includes graphics and lighting animating the existing spaces.

Bei der Umgestaltung dieses zweistöckigen Raumes wurden Holz- und Glasflächen verwendet, die von einem Stahlskelett Halt bekommen; alle Elemente sind vorgefertigt und wurden außerhalb des Geländes hergestellt. Bestandteile dieses neuen Systems sind Grafiken und Lichter zur Belebung der vorhandenen Räume.

Lors du remodelage de cet espace de deux étages, des surfaces de bois et de verre portées par un squelette d'acier ont été mises en œuvre ; tous les éléments, préfabriqués, ont été produits en dehors du complexe. Le nouveau système intègre des graphiques et des éclairages qui animent les pièces existantes.

Para la concepción del rediseño de este edificio de dos plantas se han empleado madera y superficies de vidrio sostenidas por un esqueleto de acero. Cada uno de los elementos ha sido fabricado anteriormente fuera del recinto. El nuevo sistema integra diseños gráficos y luces que reviven las estancias ya existentes.

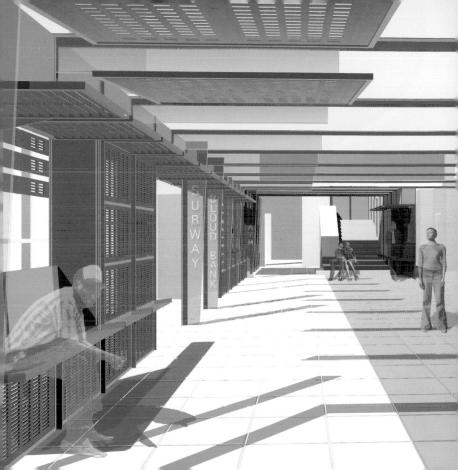

The Lesbian Gay Bisexual Transgender

Community Center

Cee Architects/Pfau Architecture LTD
Structural Design Engineers (SE)

2002
1800 Market Street
Hayes Valley

www.sfcenter.org
www.ceearchitects.com
www.pfauarchitecture.com

This competition-winning scheme in Castro district interplays between transparency and opacity to speak about relationships between sexuality and identity. Integrating a restored City Landmark Queen Anne era building on the corner of the site.

Der preisgekrönte Entwurf im Castro District ist geprägt von einem Wechselspiel zwischen Transparenz und Opazität und verkörpert die Beziehung zwischen Sexualität und Identität. An einer Ecke ist ein Wahrzeichen der Stadt integriert – ein restauriertes Gebäude im Queen-Anne-Stil.

Ce projet dans le Castro District qui a déjà été primé est caractérisé par l'entraction de la transparence et de l'opacité incarnant les rapports entre sexualité et identité. Au coin du site, le bâtiment intègre un authentique emblème restauré de la ville, un bâtiment de style néo-Reine Anne.

Este galardonado proyecto en el Castro District está caracterizado por el juego cambiante entre transparencia y opacidad, personificando de esta forma la relación entre sexualidad e identidad. La estructura integra en uno de sus extremos un edificio restaurado en estilo Queen-Anne, monumento emblemático de la ciudad.

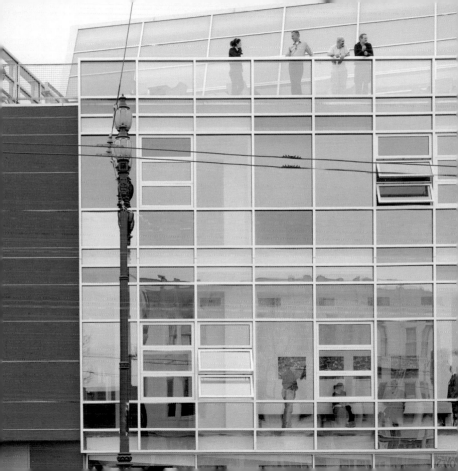

Asian Art Museum

Gae Aulenti
HOK
LDA Architects
Robert Wong Architects

2003
200 Larkin Street
Civic Center

www.asianart.org
www.hok.com

Respecting its historic elements, Beaux Arts exterior and framework, an indoor sky-lit court incorporates the prominent entrance and grand staircase providing a dramatic focus for the new museum's central space.

Mit großer Achtung vor den historischen Elementen, der Fassade und dem Rahmenwerk im Beaux-Art-Stil, sind der markante Eingang und die beeindruckende Treppe mit spektakulärem Blick auf die zentrale Museumsfläche in den Lichthof integriert.

Dans le respect des éléments historiques, de la façade et de la structure dans le style Beaux-Arts, un puits de lumière intérieur englobe l'imposante entrée et l'impressionnant escalier qui ouvre une extraordinaire perspective sur l'espace central du musée.

Respetando los elementos históricos, fachada y estructura de estilo Beaux Arts, el patio con tragaluces integra la prominente entrada y la impresionante escalera lanzando vistas arrebatadoras hacia el espacio central del museo.

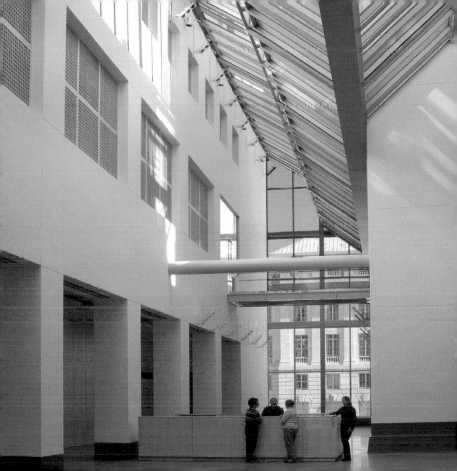

San Francisco Main Library

SMWM/Pei Cobb Freed & Partners/Kwan Henmi Architecture
OLMM Consulting Engineers (SE)

1996
100 Larkin Street
Civic Center

www.smwm.com
www.pcfandp.com
www.kwanhenmi.com

The organization of the space is centered on a grand open-staircase and a five-story sky-lit atrium connecting other architectural elements. Two exterior temperaments are used to create a link with its neighboring districts and Beaux-Arts buildings.

Die Räume sind rings um ein beeindruckendes offenes Treppenhaus und das fünfstöckige glasgedeckte Atrium angelegt, das andere architektonische Elemente miteinander verbindet. Zwei der Außenfassaden schaffen eine stilistische Verbindung zu den benachbarten Vierteln und den im Beaux-Art-Stil gehaltenen Gebäude.

L'organisation de l'espace est centrée sur une grande cage d'escalier ouverte et un atrium sur cinq étages surmonté d'une verrière qui relient d'autres éléments architecturaux. Deux des façades extérieures servent à créer un lien stylistique avec les quartiers et les bâtiments voisins restés dans le style Beaux-Arts.

El centro de la estructura del espacio lo constituye una magnífica escalera abierta y un atrio de cinco plantas con cubierta de vidrio, enlazando otros elementos arquitectónicos. Dos de las fachadas exteriores han conseguido crear un vínculo estilístico con los barrios colindantes y los edificios estilo Beaux Art.

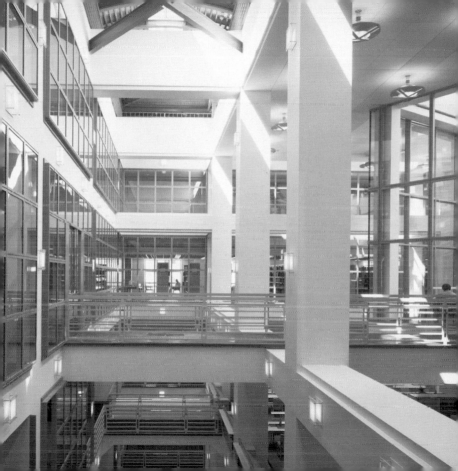

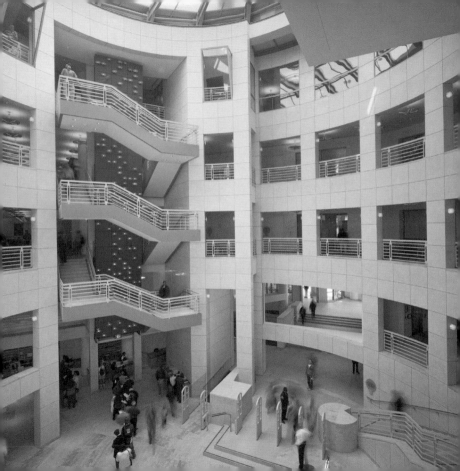

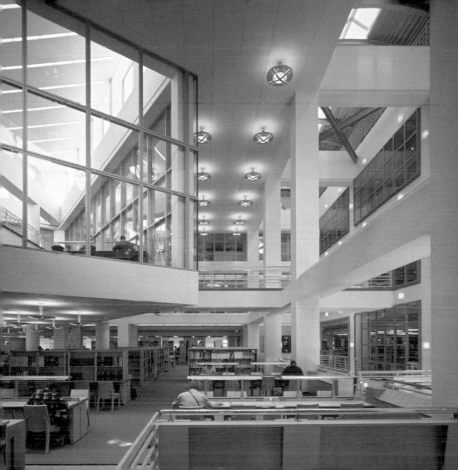

Hosfelt Gallery

Fougeron Architecture
Endres Ware Engineers (SE)

1999
430 Clementina Street
Civic Center

www.hosfeltgallery.com
www.fougeron.com

This designed minimalist gallery creates a conversation with the existing concrete frame industrial building; integrating one main gallery for large works, a smaller gallery for photographs and works on paper. A windowless gallery for video art creates a visual dramatic entrance.

Das Design der minimalistischen Galerie interagiert mit der Betonrahmenbauweise des bereits existierenden Industriegebäudes; eingegliedert sind eine Hauptgalerie für große Werke und ein kleiner Ausstellungsraum für Fotografien und Arbeiten auf Papier sowie ein fensterloser Raum für Videokunst, die dem Besucher einen spektakulären Empfang bereitet.

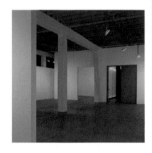

Le design de cette galerie minimaliste établit un dialogue avec le bâtiment industriel existant reposant sur une structure en béton; s'y intègrent une galerie principale pour les grandes œuvres, une petite salle d'exposition pour les photos et les travaux sur papier ainsi qu'une pièce aveugle pour l'art en vidéo qui constitue l'entrée et crée un effet saisissant.

El diseño minimalista de la galería crea un diálogo con el hormigón del edificio industrial ya existente. Integrando una galería central para obras mayores y una sala de exposiciones reducida para fotografía y obras en papel. Una galería sin ventanas para arte audiovisual crea una entrada provocadora de impacto óptico.

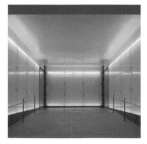

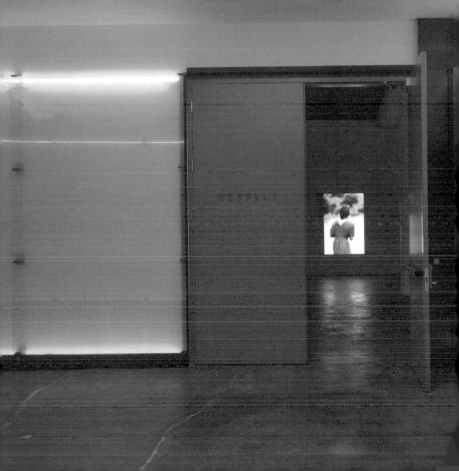

The Contemporary Jewish Museum

Daniel Libeskind/Chong Partners Architecture
Ove Arup & Partners California (SE)
OLMM Consulting Engineers (SE)

2007
Jessie Street
South of Market

www.thecjm.org
www.daniel-libeskind.com
www.chongpartners.com

Situated in an abandoned power station and keeping the old parameters, a new program and circulation were created for the visitor to experience the reconfigured spatial form of the new extension.

Das Museum befindet sich in einem stillgelegten Kraftwerk; die alten Parameter blieben. Für den Besucher wurden ein neuer Plan und ein Rundgang entworfen, damit er die räumliche Umgestaltung des Anbaus erleben kann.

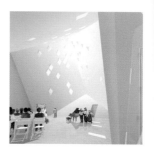

Situé dans une centrale électrique désaffectée, le musée en conserve les anciens paramètres. Un nouveau plan et circuit de visite ont été conçus pour le visiteur afin qu'il puisse explorer la réorganisation de l'espace du nouvel agrandissement.

El museo está ubicado en una central eléctrica en desuso y mantiene los antiguos parámetros. Con el fin de que los visitantes pudieran experimentar la nueva configuración espacial de la ampliación del edificio se creo un plan y recorrido de visita nuevos.

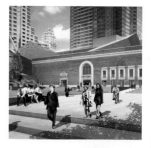

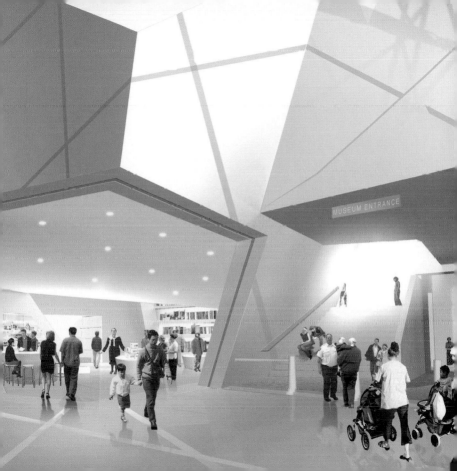

University of California, San Francisco (UCSF)

Mission Bay

Campus Community Center

Legorreta + Legorreta
Ricardo Legorreta, Victor Legorreta
MBT Architecture
Forell/Elsesser Engineers, Inc. (SE)

2005
1675 Owens Street
Mission Bay

pub.ucsf.edu/missionbay

This campus will be the vibrant center of an exciting new neighborhood. The attractive landscaped, art-filled open space will serve as the social hub of UCSF Mission Bay where leading scientists, students and the community will interact.

Dieser Campus wird das pulsierende Zentrum eines aufregenden neuen Viertels. Die landschaftlich ansprechend gestaltete und durch Kunst belebte Freifläche wird zum Treffpunkt schlechthin für die UCSF Mission Bay, zum Ort der Begegnung für führende Wissenschaftler, Studenten und die Gemeinde.

Ce campus sera le poumon d'un nouveau quartier palpitant. Cet espace ouvert, attrayant par son aménagement paysager et ses œuvres d'art, deviendra la plaque tournante sociale de l'UCSF Mission Bay où d'éminents scientifiques, des étudiants et la communauté vont interagir.

Este campus pasará a ser el centro vibrante de un nuevo distrito. Las atractivas superficies abiertas concebidas como jardines paisajísticos y decoradas con obras de arte, constituirán el centro social interactivo de la UCSF Mission Bay para científicos, estudiantes y habitantes.

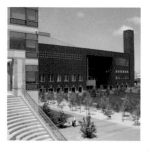

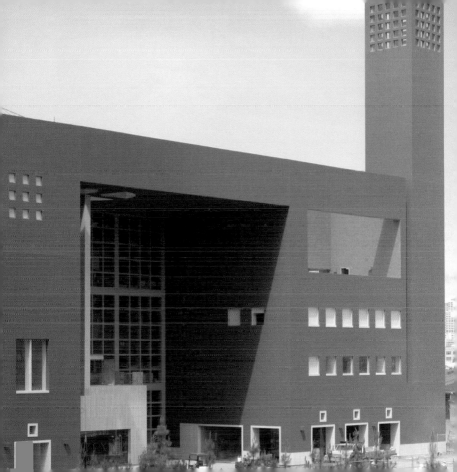

California College of the Arts (CCA)
Graduate Center

Jensen & Macy Architects
Jeffrey Weber and Associates (SE)

2003
188 Hooper Street
Potrero Hill

www.cca.edu
www.jensen-macy.com

The deteriorated 10,000 square feet wood-framed warehouse was creatively and economically transformed to house 32 individual artist studios. The exterior of the building is re-clad in corrugated cement board with a continuous clerestory of corrugated twin-wall polycarbonate.

Die verfallene, über 900 m² große Lagerhalle in Holzrahmenbauweise wurde auf kreative und ökonomische Weise in 32 individuelle Künstler-Studios umgewandelt. Die Fassade des Gebäudes wurde mit gewellten Zementplatten neu verkleidet und hat einen umlaufenden Obergaden aus gewelltem doppelwandigem Polycarbonat.

Cet entrepôt délabré de plus de 900 m² reposant sur une structure en bois a été transformé avec créativité mais économie de moyens pour recevoir 32 studios individuels d'artistes. La façade du bâtiment a été habillée de plaques de ciment ondulées et dotée d'un lanterneau circulaire en polycarbonate ondulé à double cloison.

Un almacén en ruinas de más de 900 m² en una estructura de bastidores de madera, fue transformado en 32 estudios individuales para artistas de forma creativa y económica. La fachada revestida de placas de cemento onduladas omite luz por medio de una pared de poli carbonato ondulado de doble placa.

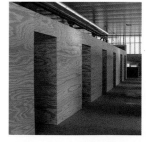

California College of the Arts (CCA), Montgomery Campus

Oliver/Blattner Studios & Jewett Studios

Jensen & Macy Architects
Ove Arup & Partners California (SE)

1999
1111 8th Street
Potrero Hill

www.cca.edu
www.jensen-macy.com

Spaces are a reinterpretation of a standard off-the-shelf industrial framing system forming a field of multiple sky-lit workshops. The scheme of the Jewett Studios consists of white planes allowing painters to work in three dimensions.

Bei diesen Gebäuden wurden für die Räume serienmäßig produzierte Gerüste so umgebaut, dass eine Fläche mit mehrere durch Fensteroberlichter ausgeleuchteten Ateliers entsteht. Kernelement des Entwurfs der Jewett Studios sind weiße Flächen, die Künstlern das Arbeiten in drei Dimensionen ermöglichen.

Les espaces sont une réinterprétation des bâtis industriels standard grâce auxquels se crée une rangée de plusieurs ateliers éclairés par des impostes. Le projet de Jewett Studios se fonde sur des surfaces blanches permettant aux artistes de travailler en trois dimensions.

Los espacios son una reinterpretación de los andamios construidos en serie, a través de los cuáles se crea una extensión con varios talleres iluminados por claraboyas. El diseño de los Jewett Studios se basa en superficies blancas que posibilitan a los artistas trabajar en tres dimensiones.

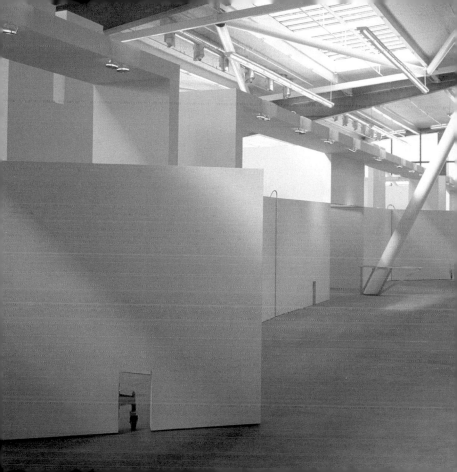

California College of the Arts CCA
Montgomery Campus

Leddy Maytum Stacy Architects, William Leddy
Ove Arup & Partners, San Francisco (SE)

1999
1111 8th Street
Potrero Hill

www.cca.edu
www.lmsarch.com

The solar-heated progressive educational environment consists of 75,000 square feet of new studios, workshops, and exhibition space. Reducing the entire building energy use with roof-mounted hot water solar collectors and a radiant floor system by 60%.

Das solarbeheizte, progressive Studien-Ambiente umfasst eine Fläche von fast 7000 m² mit neuen Ateliers, Werkstätten und Ausstellungsräumen. Über Heißwassersonnenkollektoren auf dem Dach und durch die Fußbodenheizung kann der gesamte Energieverbrauch des Gebäudes um 60% gesenkt werden.

Cet organisme éducationnel innovateur, à chauffage solaire, s'étend sur presque 7000 m² avec de nouveaux studios, des ateliers et des salles d'exposition. Grâce aux capteurs solaires à eau chaude montés sur le toit et au chauffage rayonnant au plancher, la consommation totale d'énergie du bâtiment a diminué de 60%.

Se ha creado un ambiente de estudio progresivo con calefacción solar que comprende una superficie de casi 7000 m² con estudios nuevos, talleres y salas de exposiciones. El consumo energético del edificio llega a reducirse un 60% gracias a una instalación de colectores solares de agua caliente y calefacción de suelo.

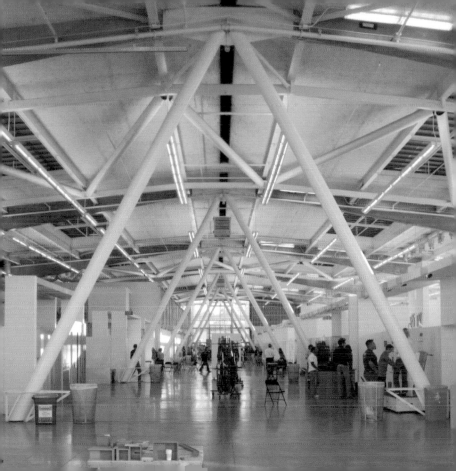

Lick-Wilmerding High School

Pfau Architecture LTD
Tipping Mar + Associates (SE)

2003
755 Ocean Avenue
Ingleside

www.lwhs.org
www.pfauarchitecture.com

The new technology and design center, a competition-entry scheme school integrates natural ventilation and recycled materials; photovoltaic and wind generated power elements contribute to the design

In dem neuen Technologie- und Design-Center, einer preisgekrönten Modellschule, sind natürliche Belüftung, Recycling-Materialien sowie Fotovoltaik- und Windenergieanlagen integriert und Bestandteil des Designs.

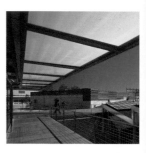

Le nouveau centre de design et de technologie, une école de maquettage souvent primée, met en œuvre une ventilation naturelle et des matériaux de recyclage. Des équipements à énergie captée et photovoltaïques sont partie intégrante du design.

El nuevo centro de tecnología y diseño es un modelo de colegio galardonado, que integra la ventilación natural y los materiales reciclados. El diseño se revaloriza a través de los elementos energéticos fotovoltaicos y eólicos.

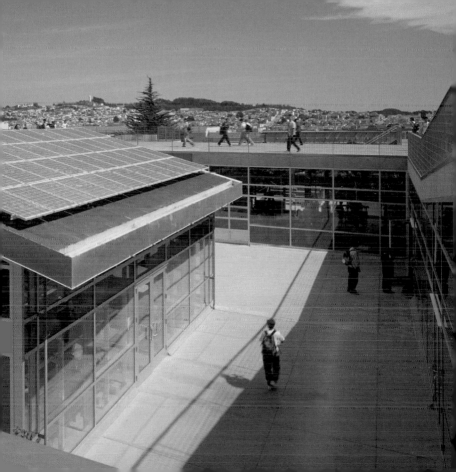

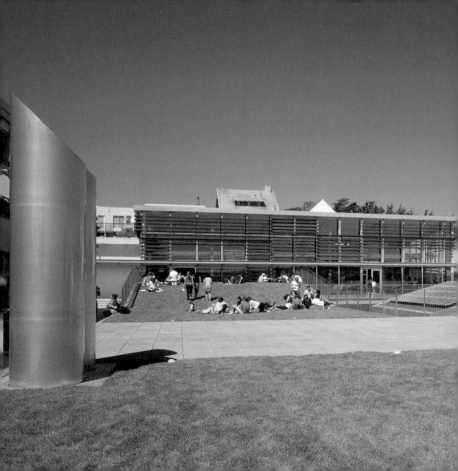

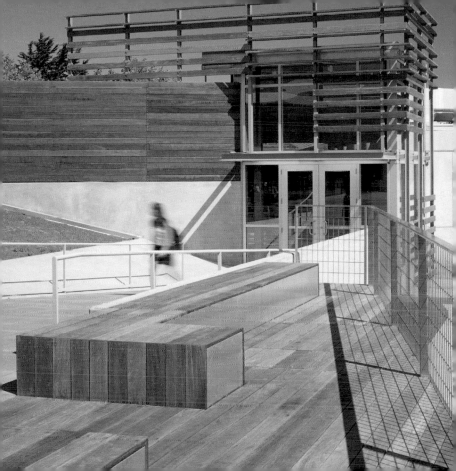

Federal Plaza SF

Della Valle + Bernheimer Design LLP
Del Campo & Maru, SF (SE)

2000
450 Golden Gate Avenue
Civic Center

www.d-bd.com

The additional installations to the plaza consist of a canopy structure and a long triangular stage. The canopy structure diffuses light while the stage made of taun wood allows speakers and performers to stand at a set location monitored by the Federal Marshals.

Die Ergänzungen des Platzes bestehen aus einer Baldachinkonstruktion und einer Bühne in Form eines langgezogenen Dreiecks. Die Baldachinkonstruktion diffundiert Licht, und auf der aus Taun-Holz bestehenden Bühne befinden sich Sprecher und Darsteller an einem Standort, der durch die Bundespolizei überwacht werden kann.

La Plaza s'est vu adjoindre une sorte de dais et une scène en forme de triangle allongé. Le dais diffuse la lumière et la scène en bois de taun permet aux orateurs et aux acteurs de se produire dans un espace délimité qui peut être surveillé par la police fédérale.

Las ampliaciones llevadas en el extremo oeste de la plaza se componen de una construcción de baldaquín y un escenario de forma triangular alargada. La construcción de baldaquín dispersa la luz y el escenario de taun permite a actores y oradores estar en un espacio fijo controlado por la Official Federal.

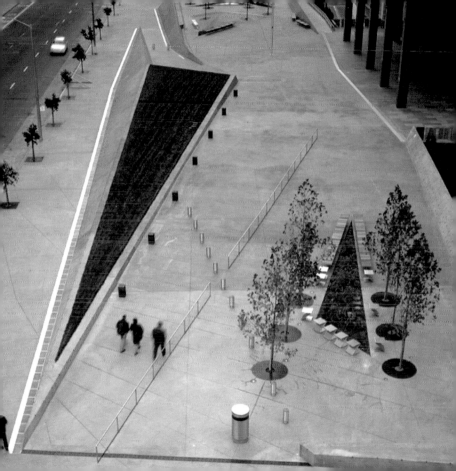

Ferry Building

Renovation

SMWM
Baldauf Catton Von Eckartsberg (Retail Architects)
Page & Turnbull (Historic Preservation)
Rutherford & Chekene (SE)

2003
The Ferry Building
The Embarcadero

www.ferrybuildingmarketplace.com
www.smwm.com

What used to be the city's main transportation hub for a half-century has now been converted into a great public market hall. Major east-west passages create a permeable ground floor that connects The Embarcadero and the Waterfront.

Ein halbes Jahrhundert lang war dieses Gebäude für San Francisco die wichtigste Drehscheibe im Transportwesen. Nun wurde es in eine riesige öffentliche Markthalle verwandelt. Große Ost-West-Passagen machen das Erdgeschoss durchlässig, das die Flaniermeile The Embarcadero mit dem Ufer verbindet.

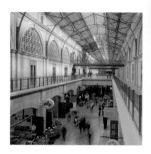

Ce qui, pour San Francisco, a été pendant un demi-siècle la plaque tournante du transport a maintenant été transformé en un grand marché couvert public. De vastes passages est-ouest rendent le rez-de-chaussée perméable, reliant la grande promenade The Embarcadero au bord de mer.

Lo que durante la mitad de un siglo fue el núcleo de transporte en San Francisco, ha sido transformado en un gran mercado. Los pasajes Este-Oeste crean una planta baja permeable que enlaza The Embarcadero con los muelles.

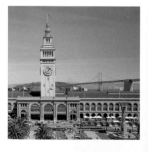

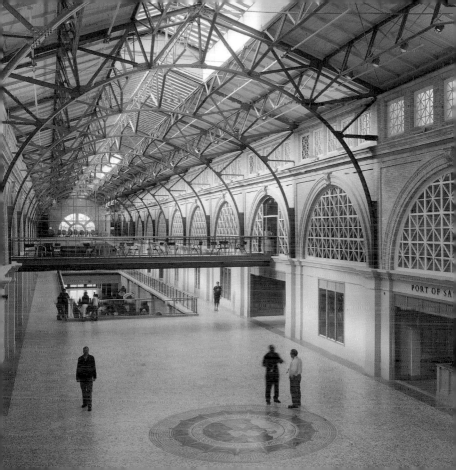

Pier 1

SMWM
Rutherford & Chekene (SE)

2001
Pier 1
The Embarcadero

www.smwm.com

This innovative design solution integrates and exposes the character of the site; utilizing "green" materials and providing over an acre of new public shoreline access. Both the public lobby and gallery describe the rich history of San Francisco's waterfront.

Das innovative Design bringt den Charakter des Gebäudes zur Geltung. Das Es verwendet „grüne" Materialien und bietet mehr als 4000 m² zusätzlichen öffentlichen Raum am Ufer. Sowohl die öffentliche Lobby als auch die Galerie legen Zeugnis von der reichen Geschichte des Hafens von San Francisco ab.

Le concept innovateur de design tient compte du caractère du bâtiment et le met en valeur; il fait appel à des matériaux « verts » et offre plus de 4000 m² supplémentaires d'espace public au bord de l'océan. Le lobby ouvert au public aussi bien que la galerie témoignent de l'histoire très riche du port de San Francisco.

Una innovadora solución de diseño integra y realza a la vez el carácter del edificio. Esta estructura emplea materiales ecológicos y ofrece 4000 m² de espacio abierto a orillas del Pacífico. Tanto el vestíbulo público adjunto como la galería se hacen testigos de la densa historia de los muelles de San Francisco.

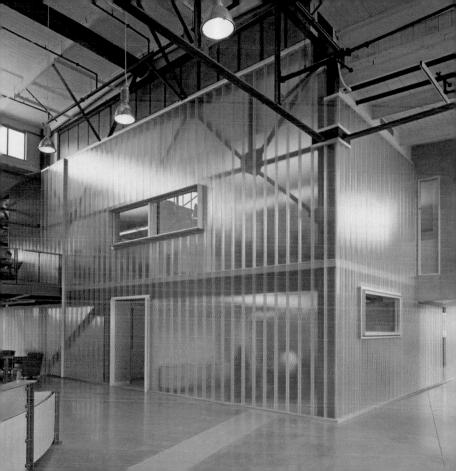

Hallidie Plaza Elevator

Michael Willis Architects
SOHA Engineers (SE)

1997
Market, Powell & 5th Street
South of Market

www.mwaarchitects.com

This three stop steel elevator provides disabled access to a below-surface plaza, the San Francisco Visitor Center and the Powell Street MUNI/BART station. Its sculpted form is wrapped with perforated external screen walls creating patterns of light and shadow.

Der Aufzug mit drei Stationen bietet einen behindertengerechten Zugang zu der tiefer gelegenen Plaza, dem San Francisco Visitor Center und der Powell Street MUNI/BART Station. Das bildhauerisch bearbeitete Äußere ist von durchbrochenen Außenwänden umgeben – ein Spiel von Licht und Schatten kann entstehen.

L'ascenseur à trois niveaux assure l'accès des handicapés à la Plaza en contrebas, au San Francisco Visitor Center et à la station MUNI/BART de la Powell Street. Sa forme ouvragée est entourée de parois extérieures perforées produisant des jeux d'ombre et de lumière.

El ascensor de tres paradas cuenta con un acceso para minusválidos a la plaza inferior, al San Francisco Visitor Center y estación MUNI/BART Powell Street. Su forma escultural está revestida en paredes de telas metálicas creando patrones de luces y sombras.

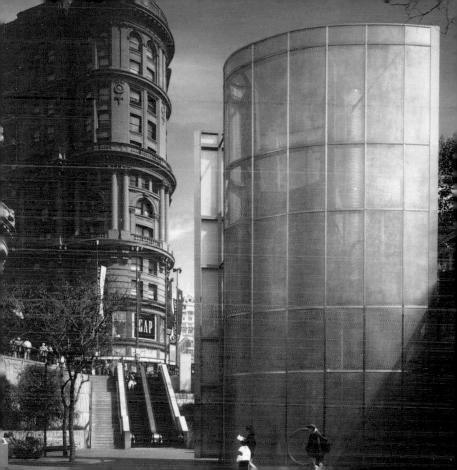

Yerba Buena Gardens Children's Center

Santos Prescott and Associates
LDA Architects
M. Paul Friedberg and Associates (Landscape Architect)
SOHA Engineers (SE), Johnson and Neilsen (ice rink) (SE)

1998
4th & Howard Streets
South of Market

www.yerbabuenagardens.com
www.yerbabuenaarts.org
www.santosprescott.com
www.ldaarch.com

Located on the roof of the below grade Moscone Convention Center, the new complex includes an indoor ice skating center, as well as a children's center focusing on technology and arts and other related programs. The multilevel circulation system allows a direct connection to the surrounding blocks.

Zu dem neuen Komplex auf dem Dach des unterirdischen Moscone Convention Center gehören eine Eislaufhalle, ein Zentrum für Kinder mit Schwerpunkt Technologie und Kunst und andere ähnliche Angebote. Über ein Wegesystem auf mehreren Ebenen besteht eine direkte Verbindung zu den benachbarten Blocks.

Le nouveau complexe situé au-dessus du Moscone Convention Center souterrain coprend une patinoire, un centre pour enfants focalisé sur les arts et technologies et autres activités connexes. Un système de circulation sur plusieurs niveaux assure une liaison directe avec les blocs voisins.

El nuevo complejo está ubicado en el tejado del subterráneo Moscone Convention Center y alberga una pista de patinaje sobre hielo, un centro infantil enfocado el desarrollo tecnológico y artístico y otros programas similares. A los bloques colindantes se accede a través de un sistema de enlaces a varios niveles.

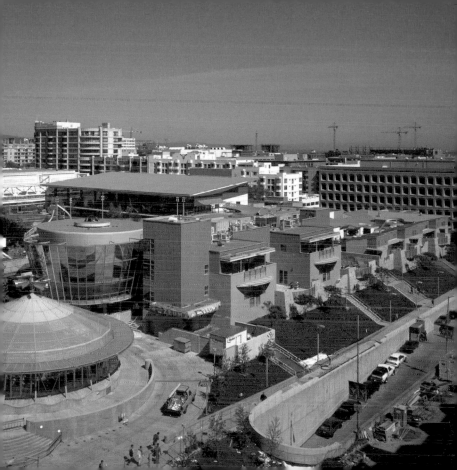

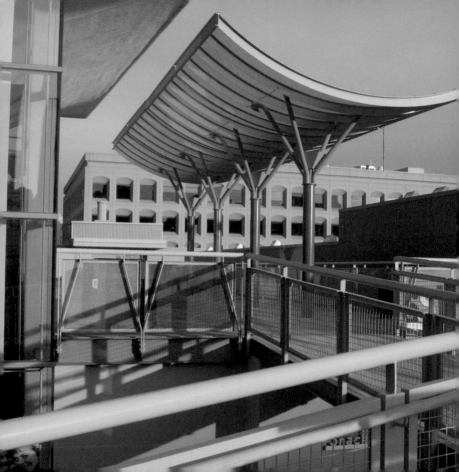

Moscone West

Gensler/Kwan Henmi Architecture/Michael Willis Architects
Structural Design Engineers (prime) (SE)
Faye Bernstein & Associates (foundations and cladding) (SE)

2003
4th & Howard Streets
South of Market

www.moscone.com
www.gensler.com
www.kwanhenmi.com
www.mwaarchitects.com

The new three-story Moscone West provides a visible link to Moscone North and South. This stand-alone facility consists of flexible spaces for exhibition and other programmatic elements; its strong and transparent form serves to invigorate the facility at the street level.

Das neue dreistöckige Moscone West hat eine sichtbare Verbindung zu Moscone North und South. Die freistehende Anlage besteht aus flexibel aufteilbaren Räumen für Ausstellungen und andere programmatische Elemente; die kraftvolle, transparente Form dient dazu, die Einrichtung auf Straßenniveau zu beleben.

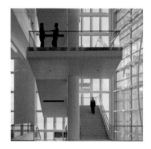

Le nouveau Moscone West à trois étages assure une connexion visible avec Moscone North et South. Cette installation indépendante est constituée d'espaces modulables pour des expositions ou autres événements programmables ; sa forme puissante et transparente renforce l'impression laissée par le bâtiment à partir de la rue.

El nuevo edificio de tres plantas Moscone West está conectado visiblemente con Moscone North y South. Esta instalacion independiente se compone de estancias flexibles para exposiciones y otra serie de elementos programáticos. La soberbia estructura transparente vista desde la calle causa verdadero impacto.

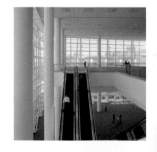

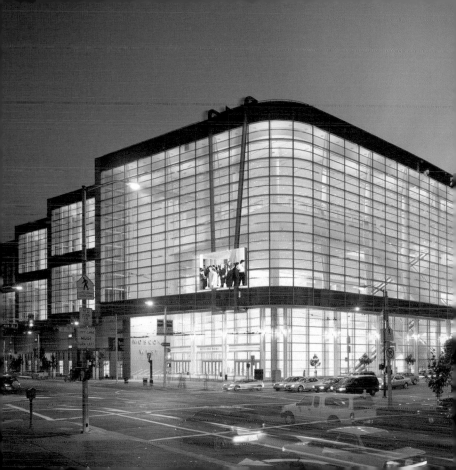

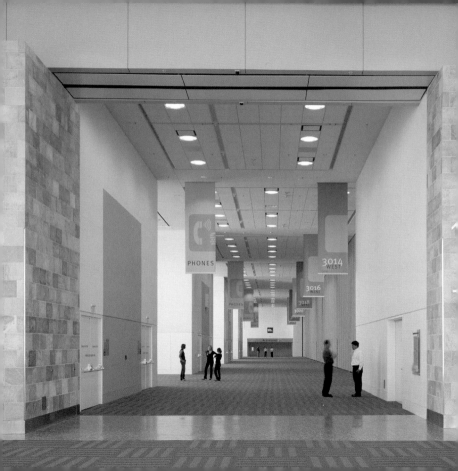

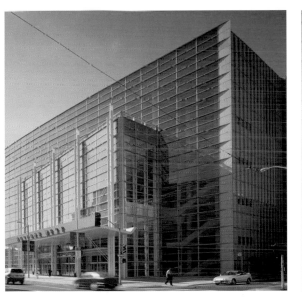
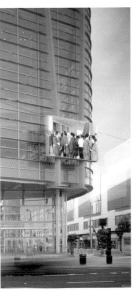

New International Terminal Building

SFO

San Francisco International Airport

Skidmore, Owings & Merrill LLP
Michael Willis Architects
Del Campo & Maru
Skidmore, Owings & Merrill LLP (SE)

2000
San Francisco International Airport
South San Francisco

www.flysfo.com
www.som.com
www.mwaarchitects.com
www.dcmsf.com

In order to meet the increasing demand in air traffic a new terminal building was designed accommodating two boarding areas and other programmatic elements. A soaring 80-foot high arched roof spanning in the 700-foot long departure hall and a structural lacy steel truss work and glass are the prime features.

Um die steigende Nachfrage zu bewältigen, wurde ein neues Terminal-Gebäude mit zwei Boarding-Zonen und anderen programmatischen Elementen entworfen. Charakteristisch sind das aufstrebende, mehr als 24 m hohe, gewölbte Dach, das die über 200 m lange Abfertigungshalle überspannt, und das filigrane Tragwerk aus Stahl und Glas.

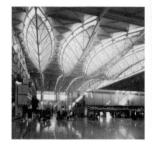

Pour répondre à l'augmentation du trafic aérien, un nouveau terminal a été conçu qui héberge deux zones d'embarquement et d'autres éléments programmables. La construction se caractérise par la voûte de la toiture haute d'au moins 24 m qui couvre les plus de 200 m de la salle d'enregistrement, et par la structure porteuse d'acier et de verre.

Con el fin de cubrir la creciente demanda del tráfico aéreo se proyectó una nueva terminal que alberga dos zonas de embarque y otros elementos programáticos. La característica principal es un techo abovedado que supera los 24 m de altura y recubre un pabellón de más de 200 m de longitud, así como la estructura portante de acero y vidrio.

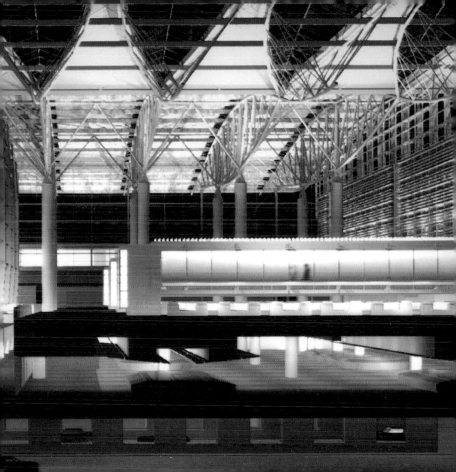

San Francisco International Airport Lounge

Virgin Atlantic Airways Clubhouse

eight Inc.
Tipping Mar + Associates (SE)

2001
San Francisco International Airport
South San Francisco

www.eightinc.com

The clubhouse is equipped with various functions and spaces, including a full-service bar and lounges for work and relaxation. The space embodies the qualities of San Francisco and clearly manifests the company spirit, its youthful culture and colorful exuberance.

Das Clubhaus ist mit unterschiedlichen Funktionen und Räumen ausgestattet, einschließlich einem Restaurant mit Bar sowie Arbeits- und Entspannungs-Lounges. Der Raum verkörpert die Eigenheiten San Franciscos und manifestiert das Gemeinschaftsgefühl, die junge Kultur und die farbenfrohe Ausgelassenheit der Fluggesellschaft.

Le Clubhouse est doté de différentes fonctions et pièces, y compris d'un bar-restaurant, de salles de travail et de salons pour la détente. L'espace incarne les qualités de San Francisco et manifeste clairement l'esprit de communauté, la culture jeune et l'exubérance colorée de la compagnie aérienne.

Una Clubhouse equipada con funciones y espacios diversos, entre ellos un bar-restaurante y lounge de trabajo y descanso. El recinto personifica las cualidades de San Francisco y muestra claramente manifesta el espiritu del la compañia, la cultura joven y exuberancia multicolor.

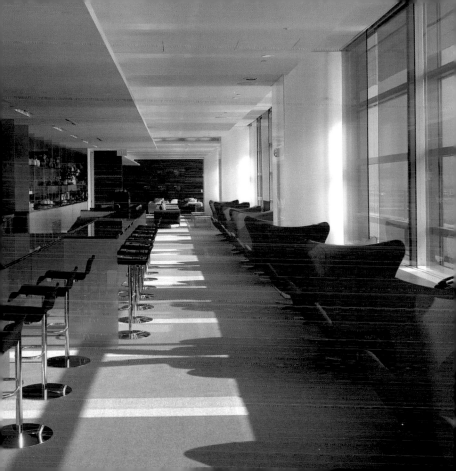

to stay . hotels

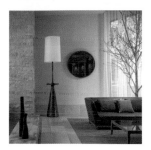
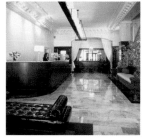
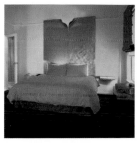
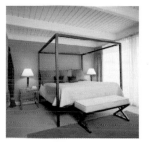
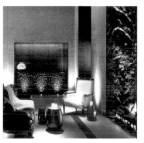
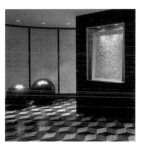
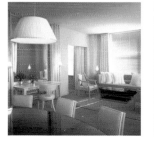
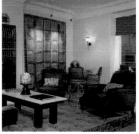
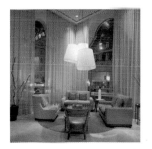

Hotel Carlton

Oren Bronstein & Marni Leis

2004
1075 Sutter Street
Nob Hill

www.jdvhospitality.com

The "international vintage" ambiance features eclectic and exotic touches from around the world celebrating the joy of travel. Guestrooms offer a soft palette of soothing tones. The expansive and unobstructed views are offered on all four sides of the building.

Das gediegene internationale Ambiente bietet eklektische und exotische Einflüsse aus aller Welt und zelebriert die Freude am Reisen. Die Gästezimmer sind in einer sanften Palette beruhigender Farbtöne gehalten. Weitschweifende und unverstellte Ausblicke bieten sich auf allen vier Seiten des Gebäudes.

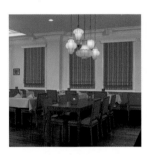

L'ambiance internationale affichée ici se traduit par des influences éclectiques et exotiques du monde entier célébrant le plaisir de voyager. Le décor des chambres tient dans une palette douce de tons apaisants. Des quatre côtés du bâtiment, les regards embrassent un panorama étendu et dégagé.

El ambiente internacional de calidad desprende influencias eclécticas y exóticas de todo el mundo que hacen alarde del gozo de viajar. Las habitaciones están decoradas en una gama de tonos suaves y relajantes. Desde todos los ángulos del edificio se disfruta de vistas vastas y libres de artificios.

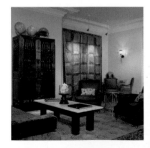

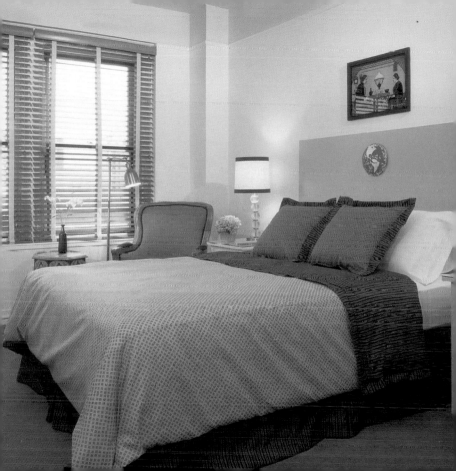

Phoenix Hotel

Charles Kopp & Pamela Wright
Martin Richards Designs (Headliner Suite)

2004
601 Eddy Street
Civic Center

www.jdvhospitality.com

Funky, irreverent and young-at-heart, this classic 1950's motel features a landmark mural at the bottom of the pool by artist Francis Forlenza ("My Fifteen Minutes"); the sculptures throughout the courtyard and the original art in all the guest rooms create an artistic fantasyland.

Unkonventionell, respektlos und junggeblieben – dieses klassische 1950er Motel präsentiert als Wahrzeichen das Gemälde „My Fifteen Minutes" von Francis Forlenza auf dem Grund seines Swimmingpools; die Skulpturen im Hof und die Originalwerke in den Gästezimmern erschaffen ein kunstvolles Fantasieland.

Funky, impertinent et jeune de cœur – ce motel classique des années 50 a fait reproduire, en guise d'emblème, la peinture « My Fifteen Minutes » de Francis Forlenza sur le fond de sa piscine ; les sculptures dans la cour et les œuvres originales dans les chambres contribuent à créer un monde de fantaisie artistique.

Al margen de los convencionalismos, irreverente y juvenil. Un motel clásico de la década de 1950, cuyo emblema es la pintura titulada "My Fifteen Minutes" de Francis Forlenza, ubicada en el fondo de la piscina. Las esculturas del patio y las originales obras expuestas en las habitaciones envuelven en un paisaje de fantasía.

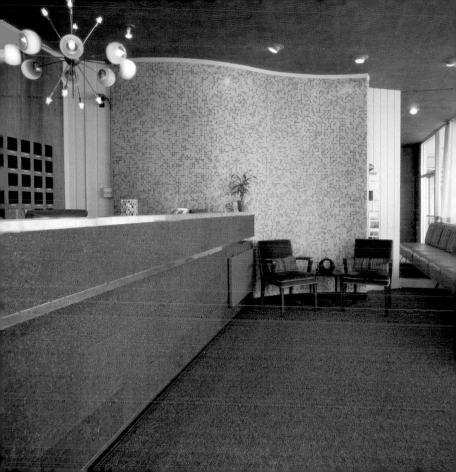

Diva Hotel

Lundberg Design
Olle Lundberg, Ian Glidden, Luke Mandle
Paul Endres of Endres Ware Engineers (SE)

1999
440 Geary Street
Union Square

www.hoteldiva.com
www.lundbergdesign.com

This Boutique Hotel has a striking stainless steel appeal. The first one that dared to be different. A sculptured steel headboard fashioned after a wave gives a cool splash to the newly renovated hotel.

Dieses Boutique-Hotel besticht durch den Reiz des Edelstahls – das erste Hotel mit dem Mut, ganz anders zu sein. Die bildhauerisch gestalteten Kopfteile der Betten, die Wellen nachempfunden sind, verleihen dem kürzlich renovierten Haus seine erfrischende Kühle.

Le Boutique Hotel a une apparence frappante, marquée par l'inox. C'est le premier hôtel qui a le courage d'être complètement différent. Les têtes de lit conçues comme des sculptures évoquant des vagues donnent à cet hôtel fraîchement rénové sa froideur rafraîchissante.

Este Boutique Hotel tiene una presencia impactante marcada por el acero inoxidable. Se trata del primer hotel con la valentía de ser completamente diferente. Los cabeceros de las camas están configurados esculturalmente en forma de ola, dando al lugar aires de frescor.

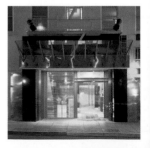

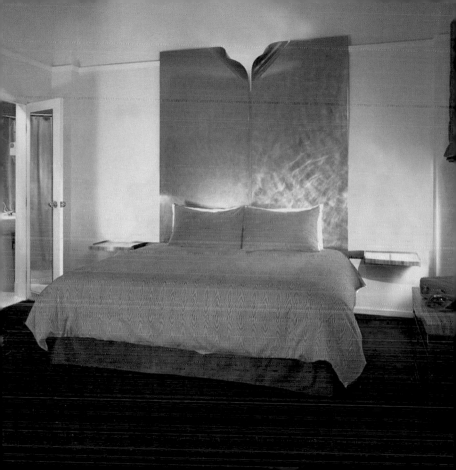

Clift

Philippe Starck

2002
495 Geary Street
Union Square

www.morganshotelgroup.com
www.philippe-starck.com

An inspired fusion of old-world hotel elegance with distinctly contemporary energy and glamour captures the city's spirit. The newly redesigned Clift features a surrealistic lobby and digital art exhibitions in its legendary Redwood Room.

Hier verschmelzen Hoteleleganz der Alten Welt und Energie unserer Zeit; der Glamour greift das Lebensgefühl von San Francisco auf. Das kürzlich umgestaltete Clift hat eine surrealistische Lobby und präsentiert in seinem legendären Redwood Room Ausstellungen digitaler Kunst.

Ici l'élégance du vieux continent se fond dans une énergie créatrice contemporaine volontaire tandis que le glamour capte l'esprit de la ville. Le Clift récemment redessiné a un hall d'entrée surréaliste et présente dans sa légendaire Redwood Room des expositions d'art numérique.

En él se funde la elegancia del viejo mundo con la intensa energía creadora contemporánea y el glamour que capta el espíritu de San Francisco. El hotel Clift ha sido remodelado recientemente y dotado de un vestíbulo surrealista. Su legendaria Redwood Room acoge exposiciones de arte digital.

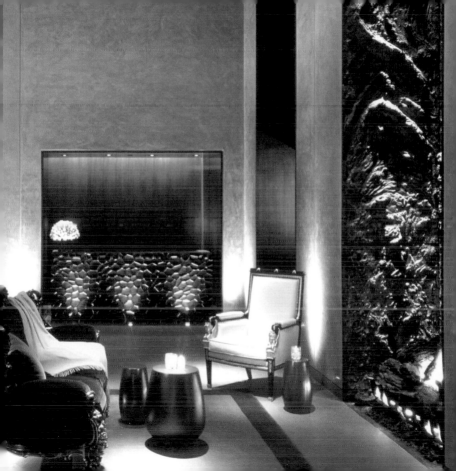

Hotel Adagio

McCartan

2002
550 Geary Street
Union Square

www.jdvhospitality.com
www.mccartan.net

The new Hotel Adagio features a light contemporary design connecting with its Spanish Colonial Revival architectural roots. Many of the 171 spacious rooms feature panoramic city views. On the 16th floor two penthouse suites with their own fireplace express the urban loft-style of the Joie de Vivre hospitality group.

Das Hotel Adagio verbindet seine architektonischen Ursprünge im Spanish-Colonial-Revival-Stil mit leichtem, zeitgemäßem Design. Viele der 171 geräumigen Zimmer bieten einen Panoramablick. Im 16. Stock bringen zwei Penthouse-Suiten mit jeweils eigenem Kamin den urbanen Loft-Stil der Joie de Vivre Hospitality Group zum Ausdruck.

L'hôtel Adagio associe ses racines architecturales de style Spanish Colonial Revival à un design léger, contemporain. Nombre des 171 chambres spacieuses offrent une vue panoramique sur la ville. Au 16ème étage deux suites penthouse incarnent le style loft urbain du Joie de Vivre Hospitality Group.

El hotel Adagio ensambla los orígenes del renacimiento de arquitectura colonial española con lo contemporáneo. Muchas de las 171 amplias habitaciones disponen de vistas panorámicas. El piso 16 cuenta con dos suites Penthouse con chimenea propia expresando el estilo de Loft del Joie de Vivre Hospitality Group.

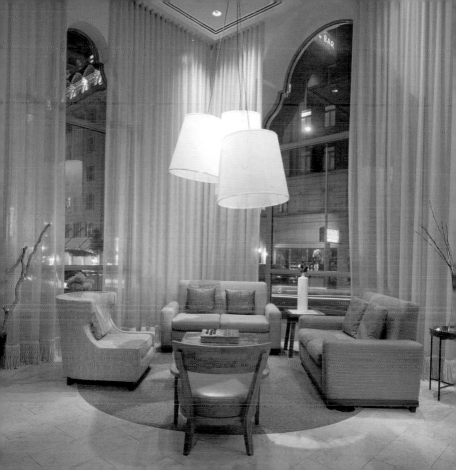

Hotel Vitale

Heller Manus Architects
McCartan (Interior Design)

2005
8 Mission Street
The Embarcadero

www.hotelvitale.com
www.hellermanus.com
www.mccartan.com

This urban oasis is surrounded by luxury touches and soothing natural elements. The new building next to the Embarcadero Waterfront offers an on-site spa with outdoor rooftop tubs, a yoga studio with terrace and its own restaurant. Many rooms have stunning views to the Bay Bridge.

Diese urbane Oase ist von einem Hauch von Luxus und beruhigenden Naturelementen umgeben. Das am Embarcadero gelegene neue Gebäude hat ein Wellness-Center mit Badewannen auf dem Dach, ein Yoga-Studio mit Terrasse und ein Restaurant. Viele Zimmer bieten eine überwältigende Aussicht auf die Bay Bridge.

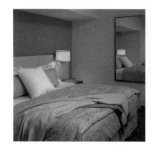

Cette oasis urbaine est entourée d'un halo de luxe et d'éléments naturels reposants. Le nouveau bâtiment situé sur l'Embarcadero dispose d'un centre de remise en forme avec des baignoires sur le toit, d'un studio de yoga avec terrasse et de son propre restaurant. De nombreuses chambres offrent une vue sublime sur le Bay Bridge.

Un oasis urbano con un toque de lujo y rodeado de relajantes elementos naturales. El nuevo hotel ubicado en Embarcadero dispone de un balneario al aire libre en el ático, estudio de yoga con terraza y restaurante propio. Muchas de las habitaciones ofrecen vistas espectaculares al Bay Bridge.

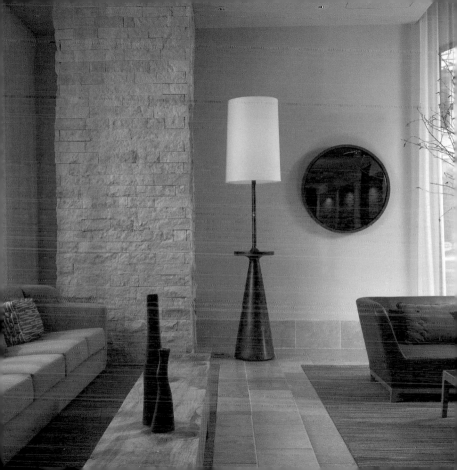

Hotel Palomar

Gensler-Charlie Cridler
Cheryl Rowley & Bob LoCoeur

1999
12 4th Street
South of Market

www.hotelpalomar.com
www.cherylrowley.com

This artful and sophisticated sanctuary showcases contemporary design with leopard skin-patterned carpeting and themed rooms including the René Magritte Suite, with a cloud-painted ceiling and unique rooms designed for tall guests with longer beds than the average ones.

Diese kunstvolle und raffinierte Stätte präsentiert zeitgenössisches Design mit Teppichen im Leopardenfellmuster sowie Themenzimmer – z.B. die René-Magritte-Suite, deren Decke mit Wolken bemalt ist – und spezielle Zimmer mit extra-langen Betten für große Gäste.

Cet établissement subtil et raffiné respire par son design contemporain qui comprend des tapis à motif léopard et des chambres à thème, telles que la suite René Magritte avec son plafond peint de nuages blancs et ses chambres hors normes pour les hôtes de grande taille meublées de lits extra longs.

Este lugar artístico y refinado está envuelto de un diseño contemporáneo, reflejado en alfombras con estampado de leopardo y habitaciones temáticas. La suite René Magritte seduce a sus huéspedes por su techo decorado con nubes y sus cuartos unicos para huéspedes de alta estatura con camas más largas a las regulares.

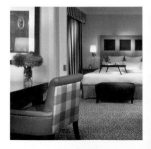

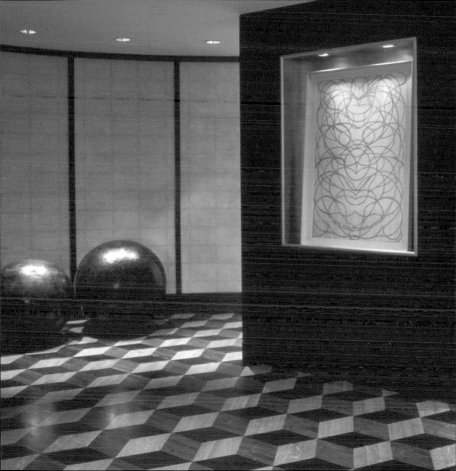

The Mosser Hotel

Your Space

2002
54 4th Street
South of Market

www.themosser.com
www.your-space.com

The elegant minimalist design of the Mosser Hotel fuses historical Victorian architecture with touches of sleek sophistication. It is the only hotel in San Francisco to feature a state-of-the-art recording studio.

Das elegante, minimalistische Design des Mosser-Hotels verbindet Viktorianische Architektur mit entspannter Raffinesse. Es ist das einzige Hotel in San Francisco, das über ein Tonstudio mit modernster Technik verfügt.

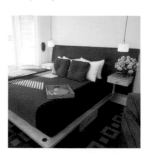

Le design minimaliste élégant de l'hôtel Mosser allie architecture victorienne et raffinement moelleux. C'est le seul hôtel de San Francisco qui possède un studio d'enregistrement équipé des technologies les plus modernes.

El diseño elegante y minimalista del Mosser Hotel es una fusión de arquitectura victoriana y suave sofisticación. Se trata del único hotel de San Francisco equipado con un estudio de grabación de tecnologias muy modernas.

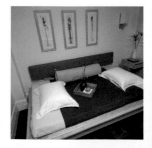

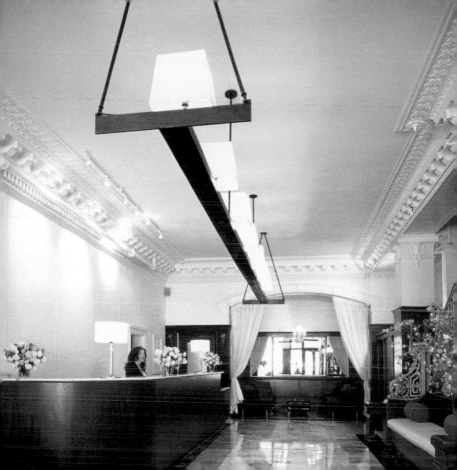

W San Francisco

Hornberger + Worstell
shopworks
Starwood Design Group
Parsons Design

1999
181 3rd Street
South of Market

www.starwoodhotels.com/whotels
www.hornbergerworstell.com
www.shopworksdesign.com

Breaking down the walls of conventional design to create a completely open lobby space, this 46 feet space makes itself notable for its unusually responsive urban design. Its innovative guestrooms and striking lobby spaces have received several awards.

Hier werden alle Regeln des konventionellen Designs für seine rundum offene Lobby gebrochen. Der 14 m lange Raum ist durch seine ansprechende urbane Gestaltung bemerkenswert. Die innovativen Gästezimmer und die beeindruckende Lobby haben mehrere Auszeichnungen gewonnen.

Entièrement ouvert, le lobby rompt avec toutes les règles du design conventionnel. La pièce qui fait 14 m de long est particulièrement remarquable par son design urbain insolite et attrayant. Les chambres innovantes et l'espace étonnant du grand lobby ont été primés à plusieurs reprises.

El lobby completamente abierto rompe todas las barreras del diseño convencional. Se trata de un espacio de 14 m especialmente llamativo por su inusual y atrayente diseño urbano. Las innovadoras habitaciones y el carácter personal de los espacios del lobby se han hecho ya con varios galardones.

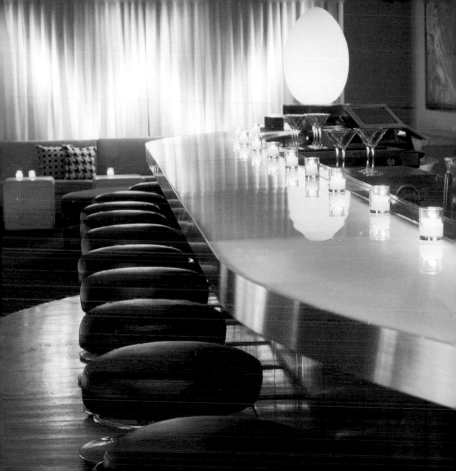

to go . eating
drinking
clubbing
wellness, beauty & sport

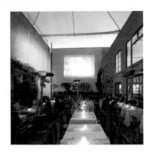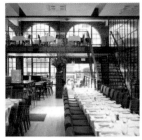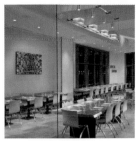
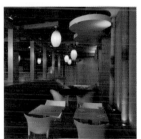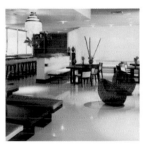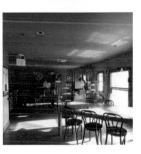
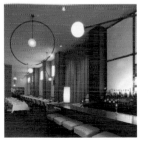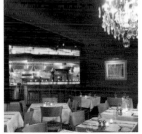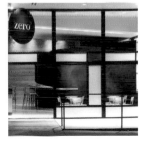

Zero Degrees Café

Mark Cavagnero Associates
Peter Culley & Associates (SE)

1998
490 Pacific Avenue
North Beach

www.cavagnero.com

Defined by brick walls and exposed wood structural beams and joists, this lofty tall space introduces new raw materials and recaptures the essential strength and vitality of the building while accommodating an entirely new infrastructure.

In dem aufstrebenden, hohen Raum mit Backsteinwänden und freigelegten Konstruktionsbalken und -trägern aus Holz sind neue Rohmaterialien miteinbezogen. Er fängt die dem Gebäude eigene Kraft und Vitalität ein und beherbergt zugleich eine völlig neue Einrichtung.

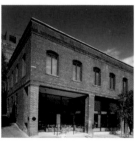

Cette pièce haute et élancée, caractérisée par des murs de brique et des poutres et supports apparents, intègre des matières premières nouvelles et maîtrise la force intrinsèque et la vitalité de ce bâtiment en accueillant une structure totalement innovatrice.

Un espacio vasto y de gran altura, con paredes de ladrillo y vigas de madera descubiertas introduce nuevos materiales brutos, renovando con ello la fuerza y vitalidad del edificio a través de una estructura y usos completamente novedosos.

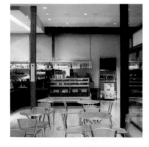

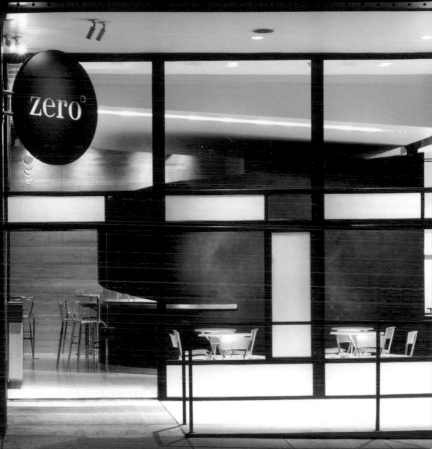

Cortez

Michael Brennan

2003
550 Geary Street
Union Square

www.cortezrestaurant.com

Michael Brennan, designer of several local haunts, allows comfort and elegance to form a modern sensibility with the use of natural materials. Earthy cork covers dining room columns, and the base of the rich mahogany bar creates a space of rustic warmth.

Michael Brennan, Designer mehrerer In-Lokale in San Francisco, lässt durch Komfort und Eleganz unter Verwendung von Naturmaterialien eine moderne Empfindsamkeit entstehen. Die mit grobem Kork verkleideten Säulen des Speisesaals und die Theke aus edlem Mahagoni schaffen eine rustikale Wärme.

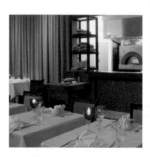

Michael Brennan, le concepteur de plusieurs établissements bien achalandés à San Francisco, crée une sensibilité moderne par le confort et l'élégance en utilisant des matériaux naturels. Les colonnes de la salle à manger recouvertes de liège grossier et le bar en acajou pur contribuent à créer un espace au charme rustique.

Michael Brennan, diseñador de otros locales muy frecuentados de San Francisco, crea una sensibilidad moderna de elegancia y confort introduciendo materiales naturales. Las columnas del restaurante revestidas de corcho tosco y la barra del bar de madera de caoba inundan la sala de una calidez rústica.

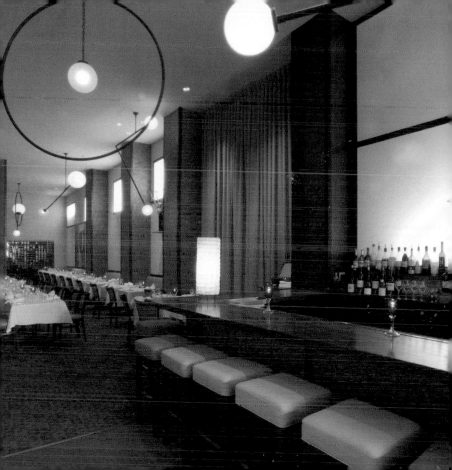

Bambuddha Lounge

Shirin Richens

2003
601 Eddy Street
Civic Center

www.bambuddhalounge.com
www.nomadika.com

Bambuddha Lounge draws on Filipino, Balinese and Thai influences to combine Miami heat and San Francisco style. The sleek, modern oasis balances cool and hot elements including floor-to-ceiling fountains and indoor/outdoor slate fireplaces.

Die Bambuddha Lounge setzt auf philippinische, balinesische und thailändische Einflüsse, um die Hitze von Miami mit dem Stil von San Francisco zu kombinieren. Die entspannte, moderne Oase stellt durch hohe Zimmerbrunnen und Indoor-/Outdoor-Schieferkamine ein Balance zwischen kühlen und heißen Elementen her.

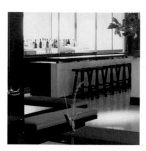

Le Bambuddha Lounge s'appuie sur des influences philippines, balinaises et thaïlandaises pour combiner la chaleur de Miami avec le style de San Francisco. Par l'intervention de cascades et de cheminées d'ardoise Indoor/Outdoor, cette oasis moderne et sereine établit un équilibre entre les éléments chauds et froids.

Bambuddha Lounge apuesta por la fusión de las influencias filipinas y balinesas con el calor de Miami y el estilo de San Francisco. Este relajante y moderno oasis brinda un equilibrio entre el calor y el frescor a través de sus fuentes de suelo a techo y chimeneas de pizarra interiores y exteriores.

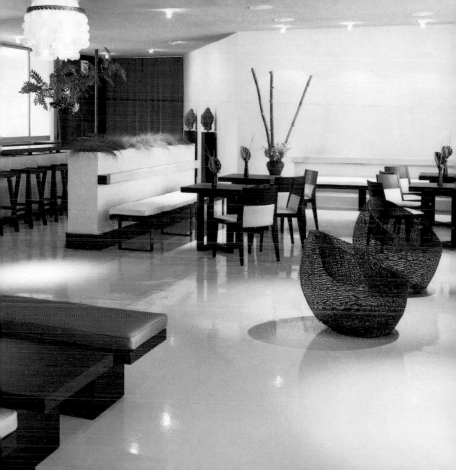

Mecca

Stephen Brady
Terra Nova Industries (SE)

1996
2029 Market Street
Upper Market

www.sfmecca.com

The interior is "industrial-luxe" featuring antique leather, velvet, zinc, stainless steel and concrete. Photography and artwork blend to form the ultimate modern dining experience for the post-dotcom crowd.

Der „Industrial-Luxe-Einrichtungsstil" verwendet Antikleder, Samt, Zink, Edelstahl und Beton. Durch Fotografie und Kunst wird die ultimativ moderne Diner-Erfahrung der post-dotcom-Generation geschaffen.

L'intérieur de style « luxe industriel » utilise du cuir antique, du velours, du zinc, de l'inox et du béton. Art et photo conjuguées créent le cadre du dîner événementiel moderne, indispensable à la génération post-dotcom.

El estilo de decoración "industrial-luxe" se expresa a través del cuero viejo, el terciopelo, el cinc, el acero inoxidable y el hormigón. Arte y fotografía se funden creando la experiencia de cena vanguardista para una generación post-dotcom.

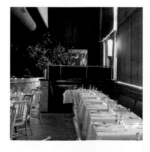

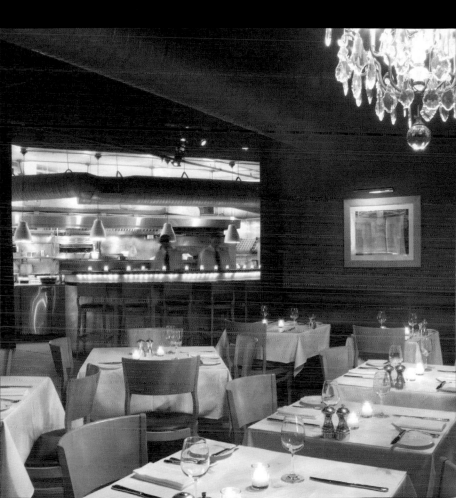

Slanted Door

Lundberg Design
Olle Lundberg, David Battenfield, Wylie Price, Jeff Loehmann
Thad Povey of Murphy Burr Curry, Inc. (SE)

2004
1 Ferry Building
The Embarcadero

www.slanteddoor.com
www.lundbergdesign.com

Olle Lundberg cleverly faces Charles Phans' restaurant and glasswork bar to the back towards amazing Bay Bridge views. The Phan family's Vietnamese cuisine features locally grown and organically farmed ingredients from the Ferry Building Farmers Market.

Olle Lundberg wendet Charles Phans Restaurant und die gläserne Bar nach hinten hin clever der überwältigenden Aussicht auf die Bay Bridge zu. Die vietnamesische Küche der Familie Phan verwendet lokale und biologisch angebaute Zutaten vom Lebensmittelmarkt im Ferry Building.

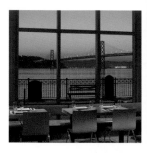

Olle Lundberg oriente astucieusement le restaurant de Charles Phans et le bar tout en verre vers l'arrière sur le panorama fascinant du Bay Bridge. La cuisine vietnamienne de la famille Phan emploie des ingrédients de culture biologique locale provenant du marché des fermiers dans le Ferry Building.

Olle Lundberg ha conseguido conformar el restaurante y la estructura de vidrio del bar de Charles Phan de forma inteligente enfocándolos hacia la embriagadora vista del Bay Bridge. La cocina vietnamita de la familia Phan emplea ingredientes locales y biológicos procedentes del mercado del Ferry Building.

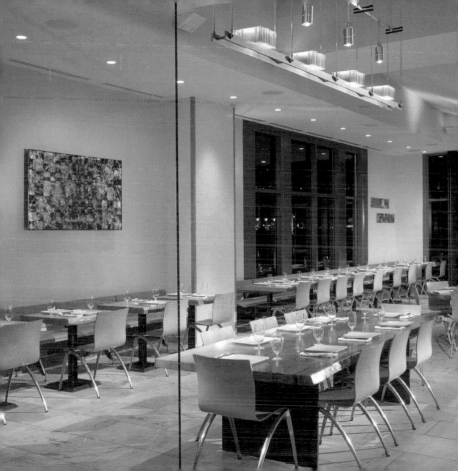

Americano

McCartan (Interior Design)
Clark Manus of Heller Manus Architects

2005
8 Mission Street
The Embarcadero

www.hotelvitale.com/dining/
www.mccartan.com
www.hellermanus.com

The artful use of natural woods on floors and dramatic arches sets the tone for the alluring and comfortable atmosphere in the restaurant and bar. The Cocktail Lounge is uniquely designed in a circular fashion offering 180 degree panoramic views of the city's famous vistas.

Der kunstvolle Einsatz von natürlichen Hölzern beim Fußboden und spektakuläre Bögen prägen die attraktive und gemütliche Atmosphäre von Restaurant und Bar. Die Cocktail Lounge hat ein einzigartiges kreisrundes Design, das einen 180-Grad-Panoramablick auf die Sehenswürdigkeiten der Stadt gewährt.

L'emploi raffiné de bois naturels au sol et les arcs spectaculaires donne le ton dans l'atmosphère séduisante et confortable régnant au bar et dans le restaurant. Le design de la Cocktail Lounge, unique par sa forme en arc de cercle, permet de profiter d'un panorama à 180 degrés sur les plus belles vues de la ville.

Un empleo artístico de las maderas naturales en los suelos y soberbios arcos marca el tono del ambiente entrañable y fresco que envuelve a este bar-restaurante. El Cocktail Lounge se caracteriza por un diseño circular único, que abre un panorama de 180 grados a las vistas más famosas de la ciudad.

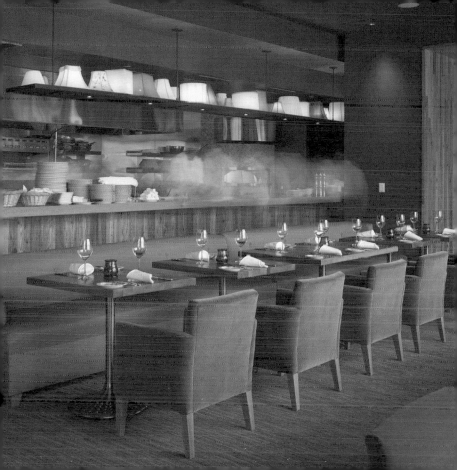

AsiaSF

John Lum Architecture

1998
201 9th Street
South of Market

www.asiasf.com
www.pacificlaundry.com

AsiaSF is a journey into exotic culinary and entertainment delights, widely known for its gender illusionists. The atmosphere and décor lit bamboo-clad walls and shoji screens under a midnight blue ceiling set the tone for your evening.

AsiaSF ist eine Reise zu den Freuden exotischer Küche und exotischen Entertainments und weithin bekannt für seine „gender illusionists". Die Atmosphäre, das Lichtdekor, die bambusverkleideten Wände und Shoji-Blenden unter der mitternachtsblauen Decke geben am Abend den Ton an.

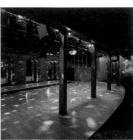

AsiaSF est un voyage dans les joies de la cuisine et du divertissement exotiques, bien connu pour ses « gender illusionists ». L'atmosphère, le décor des éclairages, les murs couverts de bambou et les cloisons japonaises sous un plafond d'un bleu nuit profond donnent le ton de votre soirée.

AsiaSF entraña un viaje hacia el gozo de la cocina y el entretenimiento exóticos, esto último gracias a sus famosos "gender illusionists". El tono lo da el ambiente, los juegos de luz, las paredes revestidas de bambú y las pantallas Shoji bajo un techo azul de medianoche.

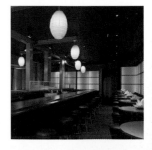

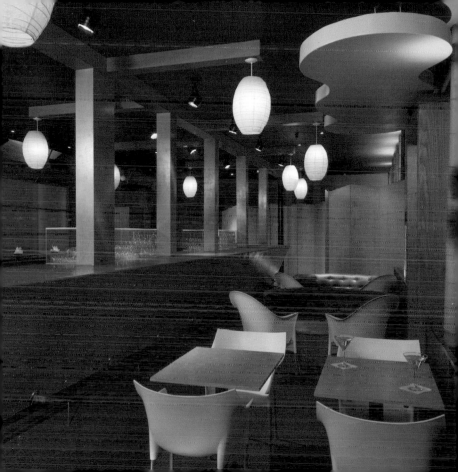

bacar

Zack / de Vito Architecture

2000
448 Brannan Street
Mission Bay

www.bacarsf.com
www.zackdevito.com

Where to become a pro at being casual. Bacar redefines comfort dining in its South of Market brick shell renovation with a modern lounge below and a hip restaurant above, it has one of the most extensive by-the-glass wine menus and professional staff in the city.

Hier wird man Profi im Lässigsein. Bacar definiert ein behagliches Abendessen in diesem renovierten Backsteinbauwerk in South of Market ganz neu. Mit der modernen Lounge im Untergeschoss und dem hippen Restaurant darüber hat es eine große Auswahl an offenen Weinen und ein professionelles Team.

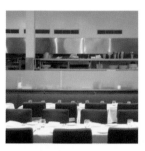

Devenez ici un pro de la nonchalance. Bacar propose une toute nouvelle définition du dîner agréable dans un établissement de brique rénové dans le quartier South of Market. Avec sa lounge moderne au sous-sol et le restaurant hip au-dessus, il propose la plus importante carte de vins au verre, servis par l'équipe la plus professionnelle de la ville.

Aquí se vive el desenfado en su máxima expresión. Bacar redescubre el placer de cenar de forma confortable en un edificio enladrillado renovado en el barrio South of Market. El moderno Lounge del sótano y el estiloso restaurante del piso superior cuentan con la mayor selección de vinos y el equipo más profesional de la ciudad.

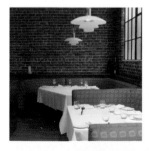

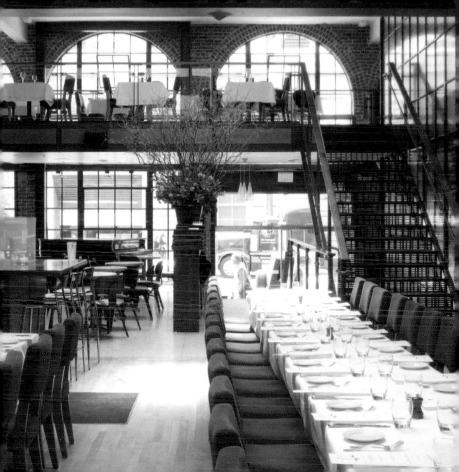

Foreign Cinema

Praxis

1999
2534 Mission Street
Mission

www.foreigncinema.com
www.praxisarchitects.com

The wood and concrete interior combine for a backdrop of businesslike warmth, accentuating dinner-time movie viewing as well as cocktail hour conversation. Floorboards and mezzanine railings were salvaged from old theatres in the area to integrate with the defunct theatre district.

Das Interieur aus Holz und Beton bietet eine Kulisse, die sowohl die Filmvorführungen beim Dinner als auch die Gespräche an der Cocktailbar betont. Die Bodenbretter und das Mezzaningeländer stammen aus alten Theatern in der Gegend und schaffen einen Bezug zum nicht mehr bestehenden Theaterviertel.

L'intérieur en bois et en béton forme un cadre mi-business michaleureux qui donne de l'intensité aux projections de film aux dîner et aux conversations autour du bar à cocktails. Le parquet et la rampe de la mezzanine provenant des anciens théâtres de la région rétablissent un lien avec le quartier des théâtres qui n'existe plus.

Los interiores de madera y hormigón se combinan con el aire negocios cálidos, acentuando las proyecciones en plena cena como las conversaciones del Cocktailbar. Los entarimados y enrejados de entresuelo son de antiguos teatros de la zona y crean vínculos con el inexistente distrito de los teatros.

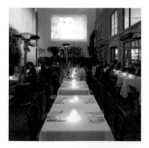

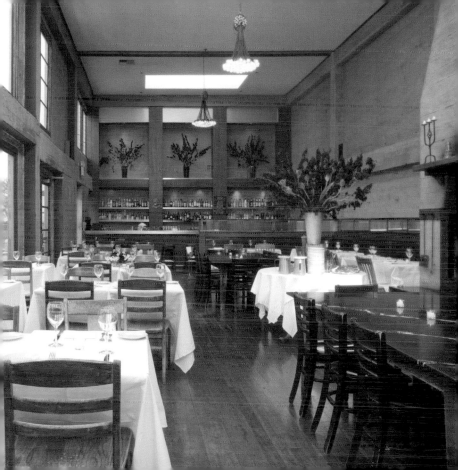

International Orange

Philip Banta
Matt Dick (Creative Consultant)

2002
2044 Fillmore Street, 2nd floor
Pacific Heights/The Fillmore

www.internationalorange.com
www.bantadesign.com

The space reinvents itself by continually changing and featuring different installations by artists and individuals from different fields. Besides exhibitions in the lounge, yoga classes and spa treatments advocate self-exploration through the environment.

Die Räumlichkeiten erfinden sich durch wechselnde Installationen von Künstlern und anderen Personen immer wieder neu. Neben den Ausstellungen in der Lounge bieten Yogakurse und Wellness-Behandlungen Raum für Selbsterfahrung.

Les pièces se réinventent en permanence grâce à la variation des installations proposées entre autres par des artistes. Parallèlement aux expositions installées dans le lounge, des cours de yoga et des soins de remise en forme invitent à prendre conscience de soi-même.

Un espacio que se redescubre a través del cambio constante que se hace presente en las diversas instalaciones de artistas y personalidades de todo tipo de ámbitos. A ello se suman exposiciones en el Lounge, cursos de yoga y tratamientos wellness que incitan a la experimentación y el encuentro personal.

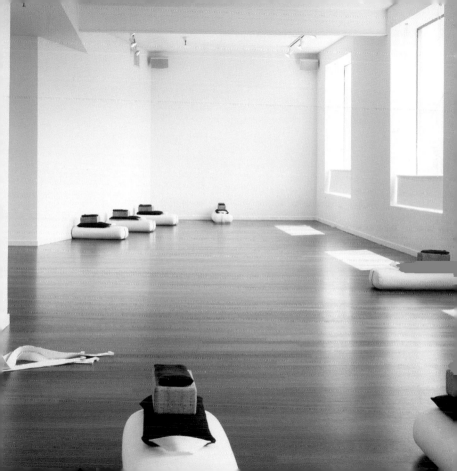

Mr Pinkwhistle

Simon Marc

2003
580 Bush Street
Union Square

www.mrpinkwhistle.com

Simon Marc, hairdresser, artist, and collector has transformed his flair and passion into a progressive showcase salon. To maximize the 20-feet ceilings, the sculptor Grant Irish created 12-feet high mirrors that swivel in 360 degrees.

Simon Marc, Haarstylist, Künstler und Sammler, hat mit Fingerspitzengefühl und Leidenschaft seinen Salon in einen progressiven Ausstellungsraum verwandelt. Um die 6 m hohen Decken zu betonen, schuf der Bildhauer Grant Irish Spiegel mit einer Höhe von über 3,5 m, die um 360 Grad schwenkbar sind.

Simon Marc, coiffeur styliste, artiste et collectionneur, a mis toute sa passion et sa perspicacité dans la transformation de son salon en salle d'exposition progressive. Afin d'exploiter du mieux possible les plafonds d'une hauteur de 6 m, le sculpteur Grant Irish a créé des miroirs hauts de plus de 3,5 m qui pivotent sur 360 degrés.

Simon Marc, peluquero, artista y coleccionista ha sabido recrear su salón con tacto y pasión como una verdadera sala de exposiciones. Con objeto de poner de relieve los techos de 6 metros de altura, el escultor Grant Irish concibió espejos de 3,5 m giratorios en 360 grados.

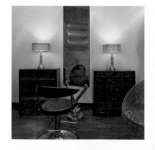

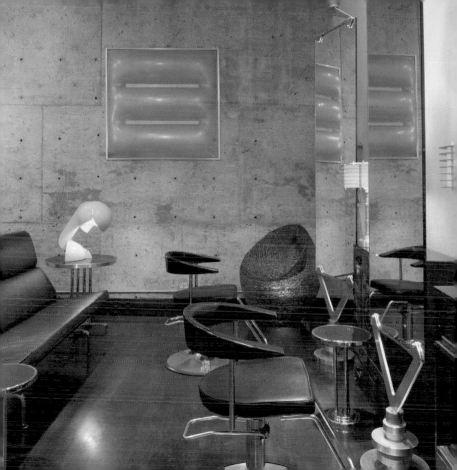

Tru

Chris Kofitsas

2003
750 Kearny Street
Financial District

www.truspa.com
www.nwdbonline.com

Clean and modern are the colors in this space, bright and airy, highlighting the fact that natural light is predominant throughout the spa. Bamboo flooring is used throughout for both its sanitary and earth friendly properties.

Klar und modern sind die Farben dieser hellen und luftigen Räume. Sie unterstreichen das in dem Spa vorherrschende natürliche Licht. Die Fußböden sind überall aus Bambus wegen seiner hervorragenden hygienischen und umweltfreundlichen Eigenschaften.

Il y a les couleurs claires et modernes de cet espace lumineux et aéré. Ceci souligne le fait que la lumière naturelle prédomine dans l'ensemble du spa. Partout le plancher est en bambou, un matériau appréciable tant pour ses qualités hygiéniques qu'écologiques.

Los colores de este espacio límpido y vaporoso son claros y modernos, acentuando así el hecho de que la luz natural es lo que prevalece en el spa. Se ha optado por los suelos de bambú dadas sus cualidades sanitarias y ecológicas.

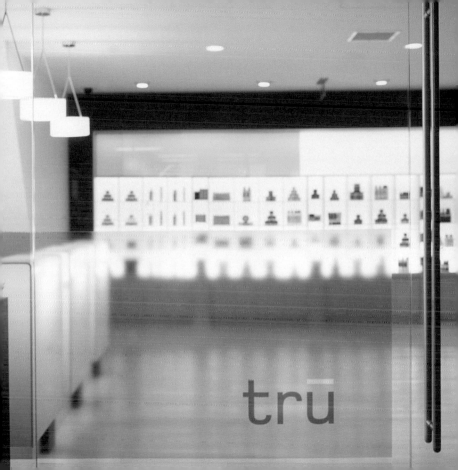

to shop . mall
 retail
 showrooms

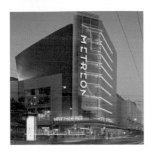

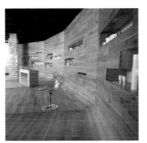
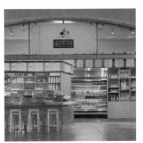
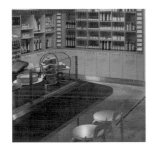
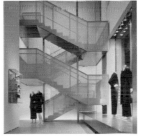
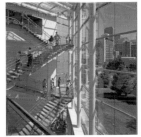

Friend

Todd Davis
fuseproject by Yves Behar

2003
401 Hayes Street
Hayes Valley

www.friend-sf.com
www.fuseproject.com

A lifestyle concept with emphasis on "life" presents a breadth of items from furniture and home furnishings to clothing and accessories all cleverly designed. Friend introduces designers and new concepts to the public on a regular basis.

Ein Lifestyle-Konzept mit Betonung auf „Life" präsentiert eine Bandbreite von Objekten in cleverem Design, von Möbeln und Einrichtungsgegenständen bis hin zu Kleidung und Accessoires. Friend stellt der Öffentlichkeit regelmäßig Designer und neue Ansätze vor.

Le concept Lifestyle mettant l'accent sur « Life » propose une palette d'objets au design astucieux, allant des meubles et articles d'aménagement aux vêtements et accessoires. Friend fait régulièrement connaître au public des designers et des approches innovantes.

Un concepto Lifestyle que sin duda acentúa el término "Life" en su amplia gama de objetos de diseño inteligente, ya sean muebles y artículos de hogar o ropa y accesorios. El objetivo de Friend es introducir al público nuevos diseñadores y tendencias.

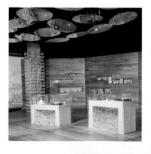

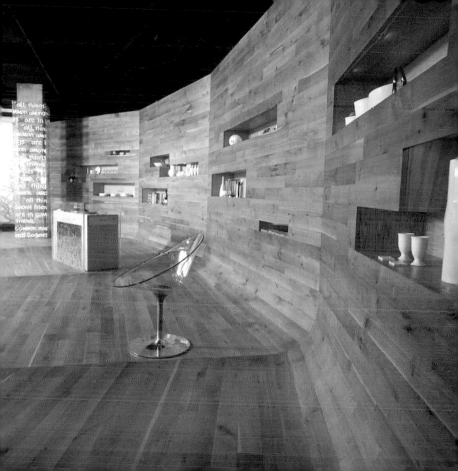

Jil Sander

Gabellini Associates
John P. Rutigiano (SE)

1996
135 Maiden Lane
Union Square

www.gabelliniassociates.com

An open environment of sunlit planes and geometric harmony allows the collection to float freely within the space. A veil of stainless steel mesh gives the staircase fluctuating qualities of opacity and transparency.

Ein offenes Ambiente aus sonnendurchfluteten Ebenen und geometrischer Harmonie lässt die Kollektion frei im Raum schweben. Ein netzartiger Schleier aus Edelstahl verleiht der Treppe den fließenden Charakter von Undurchsichtigkeit und Durchsichtigkeit.

Un environnement ouvert fait de surfaces inondées de soleil et d'harmonie géométrique laisse la collection flotter librement dans l'espace. Un voile de mailles en inox suspendu à la cage d'escalier lui confère un aspect fluctuant entre opacité et transparence.

Un ambiente abierto de superficies inundadas de luz y geometría armónica en el que las colecciones flotan suspendidas en el aire. En el velo reticular de acero inoxidable que reviste la escalera fluctúan transparencia y opacidad.

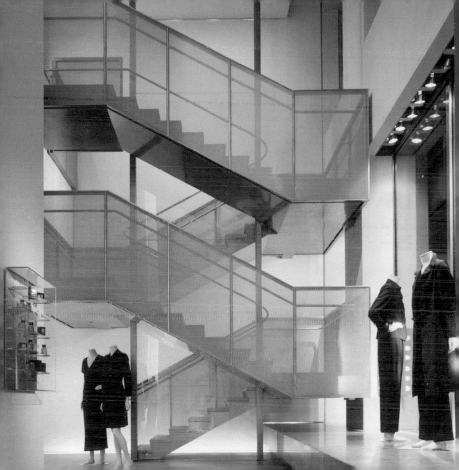

Miss Sixty & Energie

Brand + Allen Architects Inc.

2003
45 Grant Avenue
Union Square

www.misssixty.com
www.brandallen.com

This store combines two brands: Energie in the ground floor for young men and Miss Sixty for young women in the second and mezzanine shoe floor. The concept is based on a colorful space; including the use of turquoise and yellow colors and redefined ornaments of the 1960s and 1970s.

Das Geschäft kombiniert zwei Marken; Energie für den jungen Mann im Erdgeschoss, Miss Sixty für die junge Frau im ersten Stock und Schuhe im Zwischengeschoss. Das Konzept stützt sich auf farbenfrohe Räume – verwendet wurden Türkis und Gelb – und neu definierte Schmuckelemente aus den 1960ern und 1970ern.

Le magasin combine deux marques : Energie pour le Jeune Homme au rez-de-chaussée, Miss Sixty pour la Jeune Femme au premier étage, un rayon chaussures se trouvant à l'entresol. Le concept est celui de l'espace coloré – le turquoise et le jaune ont été choisis, agrémentés d'éléments de décoration revisités des années 60 et 70.

Esta tienda combina dos marcas: en la planta baja Energie, marca masculina juvenil y en la primera Miss Sixty con ropa femenina juvenil. Además dispone de un espacio de zapatería en la entreplanta. El concepto es crear un ámbito colorido, incluyendo el turquesa y el amarillo, y los elementos reinterpretados de la década de 1960 y 1970.

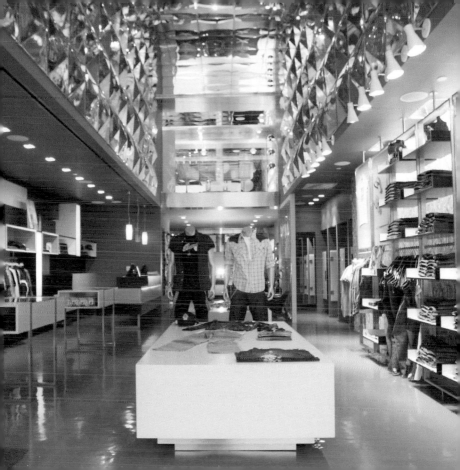

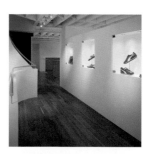

Puma

Kanner Architects

2001
856 Market Street
Union Square

www.puma.com
www.kannerarch.com

The design solution resulted in open loft spaces highlighting the diverse merchandise; with double height ceilings on both levels, an extensive use of mirrors and the white and red color palette visually expanding the energy in the space.

Die Design-Lösung besteht aus offenen Loft-Räumen, in denen die verschiedenen Waren präsentiert werden; die unterschiedlich hohen Decken auf beiden Ebenen, der großzügige Einsatz von Spiegeln und die rot-weiße Farbgebung verstärken die Dynamik des Raumes.

Le design retenu est composé d'espaces lofts ouverts qui mettent en valeur les différents articles ; les plafonds de hauteur différente sur les deux niveaux, l'usage généreux des miroirs et les couleurs rouge et blanc contribuent à accroître la dynamique du local.

La solución de diseño elegida opta por los espacios tipo loft, que destacan los diversos artículos, los techos de diferentes alturas en los dos niveles, el empleo constante de espejos y los tonos rojos y blancos que hacen ganar dinamismo a la estancia.

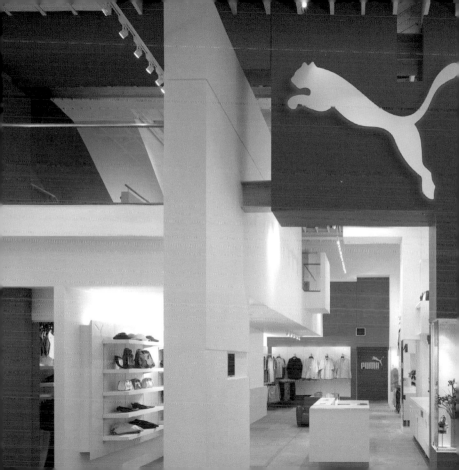

LuLu Petite

CCS Architecture

2003
The Ferry Building
The Embarcadero

www.ccs-architecture.com

Lulu Petite, a fast-casual boutique showcases gourmet food products for take away or to eat in; to express the heritage of LuLu a yellow Finnish color plywood Finply was used for almost every finish, accented by swashes of brown and stainless steel.

LuLu Petite ist eine Boutique für Fast Casual Food, wo man Gourmet-Produkte mitnehmen oder verzehren kann; als Zeichen der Verwandtschaft mit dem LuLu Restaurant wurde fast überall das gelb angestrichene finnische Sperrholz „Finply" verwendet, akzentuiert durch Verzierungen in braun und aus Edelstahl.

LuLu Petite est un magasin de restauration rapide toutes occasions qui propose des produits pour gourmets à emporter ou à consommer sur place ; pour exprimer sa parenté avec le restaurant LuLu, il emploie presque partout le contreplaqué finlandais « Finply » peint en jaune que rehausse des décorations en marron et en inox.

LuLu Petite es una boutique de comida rápida y fácil, con productos de Gourmet para llevar o tomar allí mismo. Para marcar sus vínculos con el restaurante LuLu se ha optado por una decoración en la madera finlandesa chapeada "Finply" pintada de amarillo y acentuada con ornamentos en marrón y acero inoxidable.

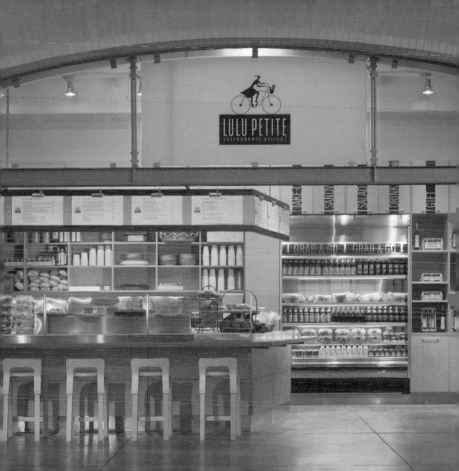

Metreon
A Sony Entertainment Center

SMWM
Gary E. Handel + Associates
SJ Engineers (SE)

1998
101 4th Street
South of Market

www.metreon.com
www.smwm.com

This new urban prototype is a media-rich retail and entertainment center combining architecture and digital culture. The 375,000 square feet program includes 15 screens and a 130-feet-tall IMAX theater sitting lightly in its site.

Dieser städtische Prototyp ist ein Verkaufs- und Entertainment-Center mit viel Medieneinsatz, das Architektur mit digitaler Kultur verknüpft. Auf der fast 3,5 ha umfassenden Fläche des Centers befinden sich 15 Kinosäle und ein trotz seiner 40 m Höhe leicht wirkendes IMAX.

Ce nouveau prototype urbain est un centre commercial et de loisirs comportant de nombreux médias et associant architecture et culture numérique. Sur une surface au sol de près de 3,5 ha se trouvent 15 salles de cinéma et un théâtre IMAX de 40 m de haut posé comme une plume sur ce terrain.

Este prototipo urbano es un centro comercial y de ocio rico en medios y dotado de una arquitectura ligada a la cultura digital. La planta tiene una extensión cercana a las 3,5 hectáreas y alberga 15 salas de cine y un cine IMAX de 40 m adaptado al espacio como un guante.

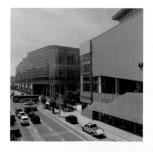

San Francisco
Florist & Gifts

Huntsman Architectural Group

1997
120 Howard Street, Suite 735
South of Market

www.huntsmanag.com

Two floral stations attract pedestrians into the space where the art of floral arrangements is revealed. The owners wanted something different than the standard and the result was a modular unique space that exhibits itself.

Zwei Blumeninseln locken den Fußgänger in den Raum, in dem die Kunst floraler Arrangements gezeigt wird. Die Besitzer wollten ein Ambiente fernab der üblichen Standards, und das Ergebnis ist ein einzigartiger baukastenartiger Raum, der selbst zum Ausstellungsstück wird.

Deux îlots de fleurs attirent les passants dans le magasin où se dévoile l'art des arrangements floraux. Les propriétaires voulaient se libérer des standards traditionnels ; le résultat est un espace modulable très original qui devient en soi objet d'exposition.

Los peatones se sienten atraídos por dos espacios florales que expresan abiertamente el arte del arreglo floral. Los propietarios querían huir de los ambientes convencionales, obteniendo como resultado un espacio a modo de pecera con verdadero carácter de exposición.

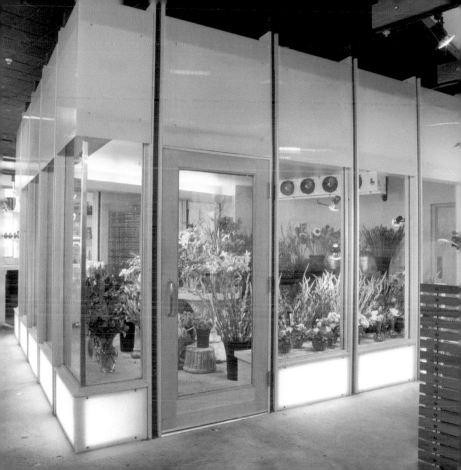

Index Architects / Designers

Index Architects / Designers

Index Structural Engineers

Index Structural Engineers

Index Districts

Index Districts

Photo Credits

Imprint

Copyright © 2005 teNeues Verlag GmbH & Co. KG, Kempen

Published by teNeues Publishing Group

teNeues Book Division
Kaistraße 18
40221 Düsseldorf, Germany
Phone: +49 211 99 45 97 0
Fax: +49 211 99 45 97 40
E-mail: books@teneues.de

Press department: arehn@teneues.de
Phone: +49 2152 916 202

teNeues Publishing Company
16 West 22nd Street
New York, N.Y. 10010, USA
Phone: +1 212 627 9090
Fax: +1 212 627 9511

teNeues Publishing UK Ltd.
P.O. Box 402
West Byfleet
KT14 7ZF, UK
Phone: +44 1932 403 509
Fax: +44 1932 403 514

teNeues France S.A.R.L.
4, rue de Valence
75005 Paris, France
Phone: +33 1 55 76 62 05
Fax: +33 1 55 76 64 19

teNeues Iberica S.L.
Pso. Juan de la Encina 2–48,
Urb. Club de Campo
28700 S.S.R.R. Madrid, Spain
Phone: +34 91 65 95 876
Fax: +34 91 65 95 876

www.teneues.com

ISBN-10 3-8327-9080-2
ISBN-13 978-3-8327-9080-6

Bibliographic information published by Die Deutsche Bibliothek
Die Deutsche Bibliothek lists this publication in the Deutsche Nationalbibliografie;
detailed bibliographic data is available in the Internet at http://dnb.ddb.de

Concept of and:guides by Martin Nicholas Kunz
Edited by Michelle Galindo
Editorial coordination by Sylvia Engel
Texts written by Melody Mason
Translations by SAW Communications, Dr. Sabine Werner, Mainz Sonja Häußler and Martina Fischer (German),
Brigitte Villaumié (French), Carmen de Miguel (Spanish)
Layout: Michelle Galindo
Imaging & pre-press: Nicole Rankers, maps, Jan Hausberg
Special thanks to AIA San Francisco (www.aiasf.org), Margie O'Driscoll and Coralie Langston Jones
for their expert advise.

fusion-publishing stuttgart . los angeles www.fusion-publishing.com

Printed in Italy

Legend

Presidio

(1)

Fulton Street

(27)

Golden Gate Park

(28)

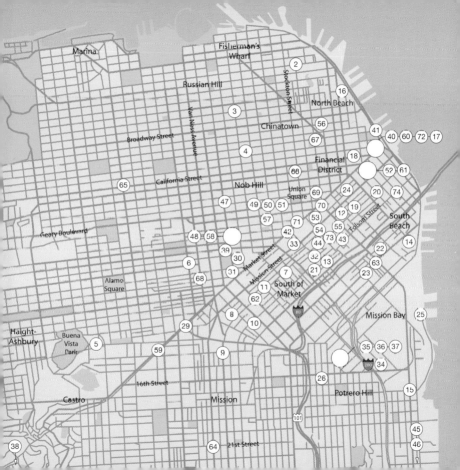

and : guide

Size: 12.5 x 12.5 cm / 5 x 5 in. (CD-sized format)
192 pp., Flexicover
c. 200 color photographs and plans
Text in English, German, French, Spanish

Other titles in the same series:

Amsterdam
ISBN: 3-8238-4583-7
Barcelona
ISBN: 3-8238-4574-8
Berlin
ISBN: 3-8238-4548-9
Chicago
ISBN: 3-8327-9025-X
Copenhagen
ISBN: 3-8327-9077-2
Hamburg
ISBN: 3-8327-9078-0
London
ISBN: 3-8238-4572-1
Los Angeles
ISBN: 3-8238-4584-5

Munich
ISBN: 3-8327-9024-1
New York
ISBN: 3-8238-4547-0
Paris
ISBN: 3-8238-4573-X
Prague
ISBN: 3-8327-9079-9
Shanghai
ISBN: 3-8327-9023-3
Tokyo
ISBN: 3-8238-4569-1
Vienna
ISBN: 3-8327-9026-8

To be published in the same series:

Dubai
Dublin
Hong Kong
Madrid
Miami

Moscow
Singapore
Stockholm
Sydney
Zurich

teNeues

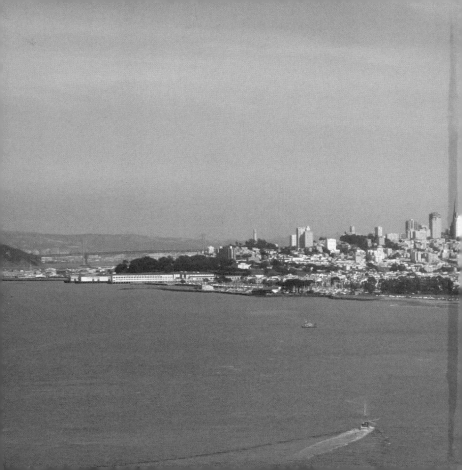